The
CHANNEL
ISLANDS
at War
A Dark History

Robert Bard

AMBERLEY

First published 2014

Amberley Publishing
The Hill, Stroud
Gloucestershire, GL5 4EP

www.amberley-books.com

Copyright © Robert Bard, 2014

The right of Robert Bard to be identified as
the Author of this work has been asserted in
accordance with the Copyrights, Designs and
Patents Act 1988.

ISBN 978 1 4456 4037 2 (print)
ISBN 978 1 4456 4070 9 (ebook)

British Library Cataloguing in Publication Data.
A catalogue record for this book is available from
the British Library.

Typesetting by Amberley Publishing.
Printed in the UK.

Contents

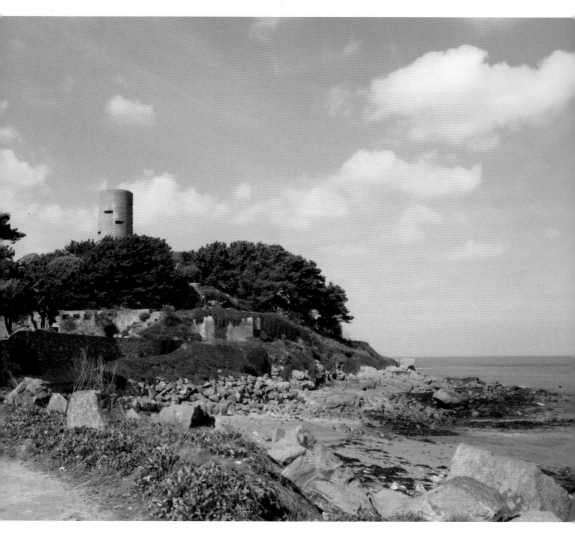

German fortifications litter the Guernsey shoreline.

Introduction

The Channel Islands were occupied on 30 June 1940, when four German planes landed at Guernsey Airport. They were the only part of Britain to be occupied during the Second World War. The islands had been officially demilitarised on 19 June, but the War Office in London overlooked the necessity to inform the Germans. This led to a German air attack on 28 June, which resulted in thirty-eight civilian deaths. Hitler was extremely proud of the conquest of the Channel Islands, and saw it as a stepping-stone to the full invasion of the rest of Britain. With this in mind, he decided that the occupants, being of 'equal racial worth', should be allowed what writer Madeleine Bunting terms a 'model occupation' in her book *The Model Occupation*. The occupying forces were instructed to behave correctly. This would show the rest of Britain that there was nothing to be feared from life under the Third Reich. This was one of the few occupations where the troops felt that the wearing of side arms was not necessary. As Bunting says, 'the Channel Islands seemed like a holiday camp to the Germans.' The propaganda factor for Hitler was tremendous, reflected in newsreels and radio broadcasts, and he issued a number of directives ordering the islands to be heavily fortified so that they would not be retaken. These fortifications remain today, mostly intact; a silent, haunting reminder of events that took place over seventy years ago. They still raise questions that divide opinion, and as yet cannot be fully answered. The German occupation opened rifts in the island communities: there were collaborators, those that simply stayed quiet, flowing with events, and those that endangered themselves to protect or feed starving slave labourers. The States governments, representatives of HM King George VI under their leaders, termed 'Bailiffs', behaved in a manner that can only be described as treasonous – the Jersey government perhaps less so than its counterpart on Guernsey.

In 1940, Germany was at the peak of her military power. The desire to win over the people of Britain meant that the now occupied Channel Islands were on display as a model of occupation. The islands became a popular place for German soldiers to take their rest and recreation. Many local women, whose boyfriends and husbands were away fighting for Britain, took German soldiers as lovers and

boyfriends. The island museums have numerous pictures showing island women socialising with German soldiers. The island governing elites mixed with Germans of equal social status and, in many cases, forged friendships that outlasted the war. In the heady days of 1940, the island governments believed it to be almost inconceivable that the German occupation would not be permanent. The Germans regarded the islanders as 'cousins' and allowed the existing island governments to remain in place under the existing Bailiffs. What happened next has led to a bitterness and acrimony that will probably remain until the events of 1940–1945 are distant history. Academics and historians are still trying to unravel the events of those years. What was clear was that there was brazen collaboration, which often led to actions by the island governments acting in a manner that, according to British law, could only be described as treason. In correspondence to a German colleague, the Bailiff of Guernsey referred to the Allies as the 'enemy forces'.

As a former pilot with Jersey European Airways and a keen yachtsman, I have had continuous contact with Alderney, Guernsey and Jersey for over thirty-five years. The islands have a rugged beauty, in many ways reminiscent of Devon and Cornwall. The most prominent features, though, are the German defences that conspicuously scar the coastlines. One is never far from either a gun emplacement or an occupation museum. More sinister are the so-called 'German Underground Hospitals', built at murderous cost to life, using mainly Russian slave labour, though paid local labour was also used. With row after row of dark, concrete corridors, steel doors and tall chimneys (or 'escape shafts'), it has been convincingly argued that these structures were originally designed as gas chambers. Alderney was evacuated and the inhabitants sent to the other islands, with the exception of a few locals who remained. The SS then set up the first and only concentration camp on British soil. Alderney effectively became nothing more than a collection of SS and Organisation Todt prison camps. Organisation Todt undertook much of the Third Reich civil and military engineering projects during the war and was notorious for using slave labour. On Alderney in particular, well-documented atrocities took place against predominantly Russian and Jewish prisoners. Today, one can still find bunkers, tunnels, barbed wire, and ominous-looking mounds on Longis Common. There are a number of plaques that recall the wartime events on what has been called 'The Island of Dread'. It would seem that a number of Dutch companies made use of, and profited from, the readily available slave labour.

Today, the seeming peace of the island, its capital St Anne and Braye Harbour hide the scars of appalling atrocities. Braye Harbour, the main entrance to Alderney, is a stern, Victorian-looking edifice with mooring buoys for visiting yachtsmen. It boasts the longest breakwater in Europe. I sometimes moor in the harbour to show sailing friends the beauty of the island and some of the chillingly disturbing occupation remains, which they would otherwise have no idea existed. A number of disturbing survivor accounts exist, which will be examined. One in particular, written by a Spanish camp survivor, describes the inhumane conditions that he and his comrades were subjected to by the SS, and provides a horrific account of the fortifying of the Braye area and Fort Albert in particular, which is now a peaceful

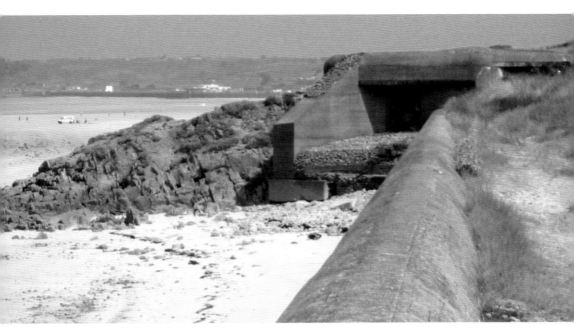

Bunker St Ouen's Bay, Jersey.

tourist spot a few hundred yards from Braye Harbour. Many prisoners died, mainly Russian and Polish, and their bodies were thrown off the surrounding high points into the harbour. Divers were sent down to clear bodies to prevent the submarine boom from clogging up. Today, yachts bob gently around on mooring buoys. For me, the harbour – for all its outward appearance of peace and tranquillity – has a dark, brooding, haunted atmosphere.

Over the years, in the course of research relating to the Channel Islands during the Second World War, it became clear to me that the islanders expected a German victory, and embraced their conquerors accordingly. It also became apparent that the only form of resistance to manifest itself on the islands occurred when it looked like Germany might not win the war. This scenario first became likely in October/November 1942, with the German defeat at El Alamein, followed by the total defeat and capture of Germany's 6th Army at Stalingrad in February/March 1943. Without any resistance, the States Parliaments, representatives of the British Government, implemented the German anti-Jewish racial policies. The remaining island Jews were rounded up, their property assessed, and they were shipped off to France, and subsequently to Auschwitz. There is evidence that British nationality managed to protect Jews who were deported in February 1943; instead of being separated, they were allowed to remain with other deported islanders. Intriguingly, after the end of the war, the island political leaders (who, it was later suggested, should have been tried for treason and hanged) were knighted for political reasons. Alexander Coutanche, the Bailiff of Jersey, who had not so blatantly served the Germans, was later given a life peerage. Others, whose behaviour could, at the

very least, be said to be questionable, were also honoured. Much of the existing documentation regarding the Channel Islanders and their behaviour was put under a 100-year lockdown until 2045, but enough is available to follow clearly the course of events. We have a good idea of the sort of material the closed files contain due to copies appearing in the Moscow State Archives, and the Holocaust Research Centre, Yad Vashem, in Jerusalem.[1] Probably the most intriguing aspect of the occupation is that it was a blueprint for the occupation of the British mainland. It was a gentle, almost gentlemanly occupation. It demonstrates the probable interaction of the British population with the Germans, should mainland Britain have been invaded. Subsequently, the occupation led to a number of studies on the nature of collaboration, and where the Channel Islands fit in. The official occupation history was published in 1975 by the late Charles Cruickshank.[2] The problem for islanders in writing island history is the complete lack of a Resistance movement and the blatant level of collaboration; both need to be dealt with if only to justify the need to work with the occupiers and justify the lack of resistance. The official guide comments that 'the islanders cannot be criticised for not starting a resistance movement. They are to be congratulated on their good sense.'[3] This could be regarded as a bland and oversimplified response to post-war accusations that there was no resistance. Balanced works tend to be lacking, as do works that place the occupation within the context of the other German occupations in nearby France, Holland, and Belgium. It has even been suggested by some islanders that the Channel Islands, in the context of resistance, were a unique case and should not be compared with mainland European resistance movements.

After the Allied defeat in France on 15 June, the British Government decided that the Channel Islands were not strategically important enough to warrant defending. The Prime Minister, Winston Churchill, thus gave up the oldest Crown possession. In Guernsey, 17,000 people out of 42,000 were evacuated. In Jersey, the majority of islanders chose to stay, and 6,600 people out of 50,000 were evacuated. Almost all of the Alderney population of 2,500 chose to leave. Evacuation boats left between 20 and 23 June. With the withdrawal of the two British representative Lieutenant-Governors, the effective government representatives were the Bailiffs, rulers of Guernsey and Jersey, who were to remain behind and to make their preparations in such a way that there would be the least disruption to the lives of the people.[4] The element of least disruption was later used to justify much that would seem questionable. Madeleine Bunting, one of the first authors to investigate the taboo themes of the occupation following the release of classified Cabinet documents in 1992, stated:

> The island governments had been told by the British Government to rule in the best interests of the islanders and they defined that duty very narrowly. They did not feel obliged to protect Jews or to comments that, speak up for slave labourers, nor to champion the cause of those islanders whom the Germans accused of misdemeanours including having resisted and who were sent to Continental prisons, where some of them died. The survival of the large majority of the islanders was at the cost of these unfortunates.[5]

A key question is whether His Majesty's representatives on the islands overstepped the boundaries between correct co-operation and the various shades and nuances leading to the charges that have been made of treason. British law is quite unambiguous in that it is an act of treason for a British citizen to hand over a British agent to the enemy in time of war, yet Ambrose Sherwill, the President of the Guernsey Controlling Committee, did just this. He 'urged' two British secret agents to give themselves up. There is documentary evidence that shows extensive co-operation with the German authorities, particularly in Jewish matters. Post-war explanation in Cruickshank's officially commissioned history of the period simply states that had the islanders refused to register the legislation desired by the Germans, it would have been enforced by decree. However, documentary evidence shows that the German masters had discretion not to implement orders that would be unsuitable for the Islands. In another work published in Guernsey, which relies on extremely uncritical island sources, the entire episode is summed up in a compact, almost perfunctory manner, ignoring any question as to by whose authority and processes these events took place:

> There were some 12 Jews in Jersey and five in Guernsey, all of whom had to register with the authorities. They were rounded up and deported and some were sent to their deaths in concentration camps. Jewish-owned shops were placarded 'Jewish Undertaking' and later Jewish businesses were ordered to be sold.[6]

Jersey women's behaviour was resented even more than the food shortage. One anonymous informant told MI19: 'The behaviour of a great number of women has been quite disgraceful. There are many illegitimate children on the island born to German fathers.' He pointed out that, under Jersey law, a husband was responsible for the upkeep of his wife's illegitimate children. The report says:

> Informants report a considerable discontent with the states administration. There will after liberation be a general demand for the incorporation of Jersey into the UK ... they speak of timidity and passive acceptance of the demands of the occupying forces. The island bosses, moreover, have lived well ... they have never gone short of food, fuel and other commodities that are in short supply for the man in the street.

A twenty-four-year-old farmer, Oscar Horman, and a clerk, Charles Bordis, who escaped to England via France after D-Day, singled out two particular racketeers: Mr Le Gresley, the food controller, and Maj. Le Masurier, president of the Supreme Council, who were accused of taking the small amount of food not commandeered by the Germans. The escapees described plans for revenge on unfaithful women. The patriotic youths, the papers say, 'have been collecting stocks of tar to publicly tar and feather all Jerrybags ... The local police are determined to turn a blind eye when the husbands return because murder will be done and public opinion will in general approve.' In an article in *The Independent* on Wednesday 2 December 1992, Stephen Ward commented:

Whitehall documents released yesterday on the German occupation of the Channel Islands reveal the extent to which the Jersey and Guernsey administrations collaborated with the occupation, and the Home Office's determination to sweep complaints under the carpet after the war. No Channel Islanders were prosecuted for war crimes or collaboration, despite extensive evidence of their help in deporting English and Jews, fraternising with the Germans and operating a black market. At the end of the war, the British even agreed to redeem marks in pounds sterling, enabling those who had accumulated wealth under the Germans to keep it. Such was the official embarrassment that the 27 folders of papers released yesterday had originally been classified for 75 or 100 years. They were released after censorship, following pressure from David Winnick, Labour MP for Walsall North. Of the files, 14 have had names removed because of 'personal sensitivity' and two on grounds of national security. Seven more have been withheld completely. The Channel Islands' own Second World War archives have never been made public, and there are no plans to release them. The records disclose that numbers of women including a surprising number of married women formerly considered respectable have carried on and lived with Germans. Illegitimate babies are common.

A secret club was set up – the Guernsey Underground Barbers – to punish women who had 'misconducted themselves' with Germans. In a report to the Home Office, Judge Fred French, who organised the evacuation of Alderney, said the Guernsey civil authorities were 'guilty throughout of a gross failure to perform their duty' by not evacuating the island earlier. One of the most telling documents, which shows that British officials and politicians chose to ignore local anger, is a private memorandum from a senior judge to the Home Secretary, James Chuter-Ede, in 1945. Lord Justice du Parcq had been asked by Home Office officials to comment on allegations of collaboration within the Jersey and Guernsey administrations. He criticises the role of the Channel Island governments in the deportation of 2,000 English and Jews to concentration camps in 1942, on Hitler's orders.

> I think that a strong case can be made ... that the authorities ought to have refused to give any assistance in the performance of this violation of international law. I have had some communication with the War Crimes Commission on the subject, and I know that the Commission has recommended the prosecution of the Germans responsible ... I should feel happier if I thought a strong line had been taken.

Of the Bailiff of Guernsey, Victor Carey, whose grandson was also Bailiff from 1999 to 2005, and who was under consideration at the time for a knighthood, he says,

> There is strong feeling in responsible quarters in Guernsey against the Bailiff by reason of the orders issued by him. Some at least were shocked by the use of the words 'enemy forces' to describe His Majesty's and Allied Forces, and by the

promise of a pounds 25 reward to any informer against a person writing the V sign (symbol of resistance) or other words calculated to offend the German authorities.

He concludes: 'I would assume that these orders, with any explanation which Mr Carey has to offer, would be brought to the attention of the Prime Minister, if not His Majesty, before any honour was conferred.' Chuter-Ede's attitude is clear, as he tells an official to write to the Bailiff asking him to comment unofficially on the allegations, and suggests the reply emphasises 'the difficulty of the main line of policy' of working under the Germans. Correspondence among legal authorities in late 1945 considers whether constitutionally there could be prosecutions against Channel Islanders. It concludes that there could not. In November, the Attorney General's office advised that even a tribunal to hear evidence against the worst collaborators would be 'undesirable'.[7]

Many islanders kept diaries that spoke of deprivation and acts of defiance. War Office documents also offer graphic accounts of relationships between island women and German soldiers, betrayal, and a thriving black market. In all, the

Longis Common, Alderney.

islands reflect a microcosm of everyday human behaviour when faced with difficult or threatening situations. What distinguishes the Channel Islands is the way in which British politicians and officials at the end of the war were reluctant to deal with something as distasteful as accusations of war crimes and collaboration on British soil. The path with the least political and social consequences was chosen – that of being seen to request reports, but doing nothing. No attempts to launch war crime trials concerning either islanders suspected of treachery or Germans guilty of mass murder on Alderney were made. With regards to Germans guilty of atrocities, their whereabouts were often known.

The story of the German occupation still raises many unanswered questions. Recent sources and events, such as the unveiling of a memorial on Jersey to its 'resistance heroes', accompanied by further relevant documentation, mean that collaboration and resistance on the Channel Islands needs closer examination, especially at a time when the Islands appear to be creating their own wartime history, which now includes a tradition of resistance. This book looks at the occupation, the unsavoury events on the islands, and why, at the end of the war, a cover-up was instigated by the British Government.

I

One Out ... One In

On 19 June 1940, the British Government decided that the strategic value of the Channel Islands was sufficiently minor that they could not afford the resources needed to defend them. Realising that invasion was inevitable, the Home Office arranged evacuation for those who wished to leave the islands, without making it too easy, for fear of swamping Weymouth with too many evacuees. Mass evacuations took place on 21 June. Of Jersey's 50,000 population, 6,500 left for England. In Guernsey, 19,000 out of 43,800 left. Government disruption was minimal. Alderney, only 7 miles distant from the French coast, was evacuated on 16 June, with the exception of eight out of the 1,400 residents. It would shortly become the first and only site of an SS-run concentration camp on British soil. On 21 June 1940, just prior to the occupation, the States of Guernsey appointed a controlling committee. The islands were in effect demilitarised. The King's message of withdrawal to the Bailiffs of Jersey and Guernsey was received on 24 June. It offered his regret and thanked the islanders for their centuries of loyalty. On 28 June, the Luftwaffe attacked both Jersey and Guernsey with machine guns and bombs, killing a number of islanders. The Germans were informed of the demilitarisation on 30 June. A photograph of 7 August shows the States of Guernsey Parliament sitting with an additional visitor, Dr Lanz, the German Commander. Depicted with him are Bailiff Victor Carey, and His Majesty's Attorney General Ambrose Sherwill. Both were prominent in the events that were to follow. The islands were politely taken over. Madeleine Bunting commented on how civilised the handover was: 'The cordial relations between the German commander and the island authorities were to be matched by the polite helpfulness of the islanders and the law-abiding soldiers.'[8]

Even the Germans were astonished at the ease of occupation. In his history of the Channel Islands published in 1942, the Island Commander, Sonderführer Auerbach inserts a chapter titled, 'How a lieutenant took over the English island of Jersey,' and comments that 'a quicker or speedy takeover such as Jersey had not been experienced in the history of the war.' Among his key observations are the significance of this being the first time the English in Europe had ever been occupied by German troops. The Channel Islands were soon to be regarded as

one of the easiest postings of the war. Bunting quotes one German, Willi Reiman, a naval rating, who comments that on the Channel Islands there was no war. The occupiers merely played at war and even enjoyed the whole experience. The islanders had been prepared to expect bullying Nazi thugs. What they were confronted with were Germans who called them 'cousins'. Again, to illustrate the very mundane nature of the occupation, Bunting quotes from a German officer, Johannes Kegelman, who remembered,

> We got on with the islanders because we had the same style of life and the same opinions. We both liked motor cars, radios and dancing and we had a lot of the same customs. I had learnt English at school and, as a young boy, we liked English things. Our parents and our history lessons told us that we were related to the British royal family. We couldn't understand why England was always fighting Germany.[9]

The proportion of troops to islanders increased until 1942 when, with an overall remaining population of 60,000, the German occupation forces peaked at 37,000. There were a number of reasons for the high number of troops. Hitler believed that were Operation Sea Lion to go ahead (the invasion of Britain), the Channel Islands would be a useful staging point, and that by transferring large numbers of troops, the British would feel threatened. With the launch of his attack against the Russians on 22 June 1941, Hitler again expressed concern that the British would take the attack as an opportunity to assist the Russians. On 19 July he stated, 'in the west and north all three elements of the Wehrmacht must be prepared to withstand possible English attacks against the Channel Islands and the Norwegian coast.'[10]

With the fear of a propaganda coup for Britain if they were to retake the Channel Islands, Hitler ordered them to be fortified, which led to the fortification of the islands far beyond any strategic purpose and the increase in troops far beyond the numbers required in order to maintain control. These troops were billeted with islanders, which led to a human interaction that in many cases overcame initial fear and suspicion. It seems to have led, if nothing else, to several hundred 'illegitimate' births.

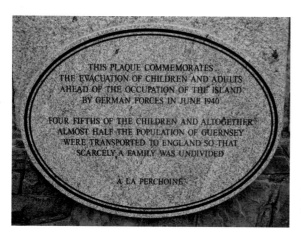

THIS PLAQUE COMMEMORATES
THE EVACUATION OF CHILDREN AND ADULTS
AHEAD OF THE OCCUPATION OF THE ISLAND
BY GERMAN FORCES IN JUNE 1940

FOUR FIFTHS OF THE CHILDREN AND ALTOGETHER
ALMOST HALF THE POPULATION OF GUERNSEY
WERE TRANSPORTED TO ENGLAND SO THAT
SCARCELY A FAMILY WAS UNDIVIDED

A LA PERCHOINE

Plaque commemorating the evacuation of children and adults in 1940, Guernsey.

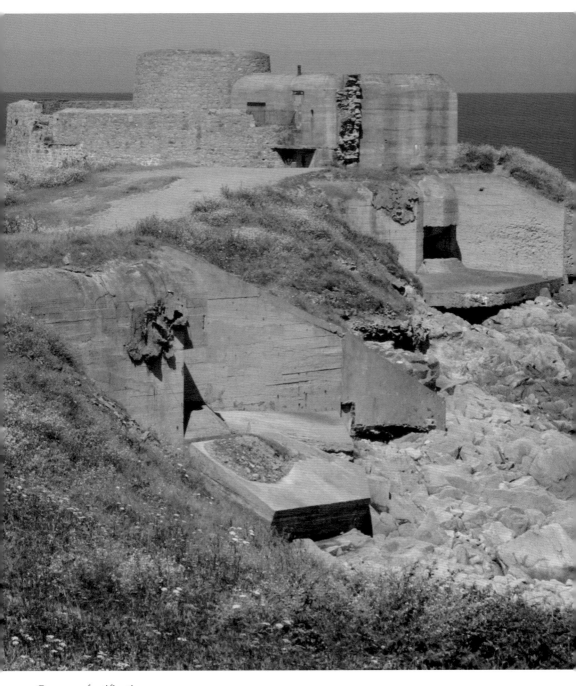

Guernsey fortifications.

2

Alderney Death Camps

Alderney is the most northerly of the Channel Islands. At only 3 square miles, it is the third smallest of the Channel Islands. It lies approximately 10 miles to the west of La Hague, Normandy, France, and has a population of around 1,700 people (2013). Today, Alderney is very much an island of moods; during autumn and winter, a dark gloom pervades during the short and often drizzle-ridden days. When I visited in July 2013 to take photographs for this book, it was a warm, sunny evening. The mood of the island was light, bright and friendly, but one is always aware of the gun emplacements and the concrete bunkers that litter the island. The events on Alderney were the darkest and most sinister of the entire Channel Islands occupation. By June 1940, most of the inhabitants of Alderney had been evacuated, and labour was brought in from Europe to construct the islands' defences. The islands were part of Hitler's 'Atlantic Wall'. In January 1942, four camps were built by a volunteer labour force of French workmen to house these workers. Each camp was named after a German North Sea island: Helgoland, Norderney, Borkum and Sylt. On 25 February 1943, an SS concentration camp under SS Sturmbannführer Maximilian List was established.

The taxi driver who took me around the sites had lived on the island for over forty years, and was only vaguely aware of what had happened. He had trouble finding the sites of the camps, even though they are marked on the island map. There are few memorials to what happened, only to those dedicated to the islanders who fought with the British and gave their lives. Unlike Jersey and Guernsey, who have built a tourist industry on the Second World War, Alderney prefers to ignore these events. Carel Toms, in his Guernsey-published book *Hitler's Fortress Islands*, comments that 'although there were hundreds of graves in Alderney after its liberation, no positive evidence has ever come to light of the alleged atrocities and mass killings which are said to have occurred.'[1] He was wrong. The evidence, as will be seen, is overwhelming.

There are a number of disturbing accounts from survivors of what occurred on the island. Just as disturbing is the manner in which, at the end of the war, the war crimes committed on the island were effectively covered up, and those known to

have been involved in the atrocities were allowed to simply disappear back into their own lives and die in their own beds. There are two hard-hitting books on the subject that ask penetrating questions. The first is *The Alderney Death Camp* by Solomon Steckoll (1982). Steckoll asks a number of pertinent questions: 'Why have important official documents disappeared?' 'Why were the Nazis responsible for war crimes on Alderney never brought to trial, even though their whereabouts after the war were known?' 'Why was there a British Government cover-up and who ordered it?' Steckoll suggests that it was the Prime Minister. The other work is *From Auschwitz to Alderney and Beyond*, by Tom Freeman-Keel. Freeman-Keel takes a direct, no-nonsense view of a number of aspects of the cover-ups, but in particular argues a compelling case for the view that the 'Underground Hospitals' on Jersey and Guernsey were meant to be gas chambers for the extermination of the enemies of the Reich.

Steckoll interviewed a number of the few survivors, including a Mr T. Misiewicz, a fourteen-year-old Polish slave worker on Alderney who was there from June

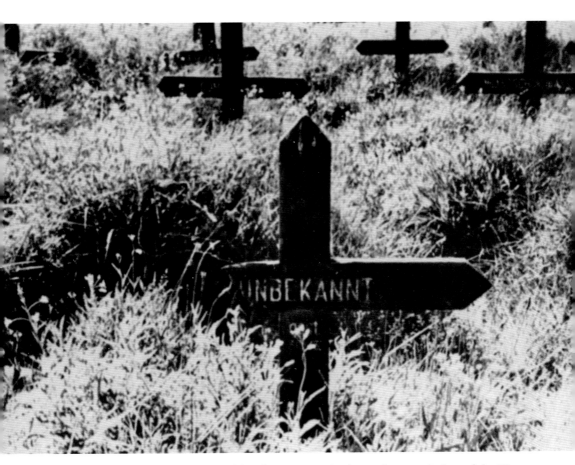

Graves on Longis Common, presumably of Russian and other unknown victims of the SS. *Unbekannt* means 'unknown'.

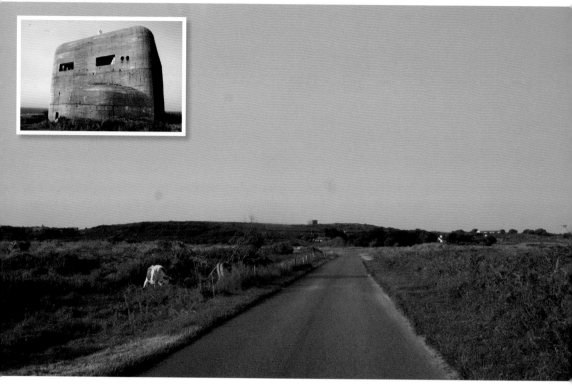

Longis Common, 2013, and Alderney fortification on Longis Common (*inset*).

1942 to December 1943 and remembered that 'from his personal recollections of what he witnessed, very many more prisoners died and were murdered than the 384 who were buried on Longis Common.' He stated,

> It was difficult to dig graves on Alderney and I saw how the dead were carried, several in a box and dumped into the harbour. The box was used over and over again. Many bodies were put into the box, it was not heavy as everybody was like a skeleton. Even the living prisoners were all walking skeletons because of the starvation rations.'[12]

Another detainee, a German political prisoner Wilhelm Wernegau, described the awful conditions in the SS Sylt camp. He describes the SS as cruel and brutal. The prisoners were made to build bunkers and fortifications:

> At one stage our camp was half empty, as around five hundred men had died from being murdered, from hard work, from starvation, and from the climate. The Russians simply couldn't take the climate … So very many of us were killed. Some were beaten to death and many more were strangled. Occasionally men were hanged. The most popular form of killing by the SS in the Sylt Concentration

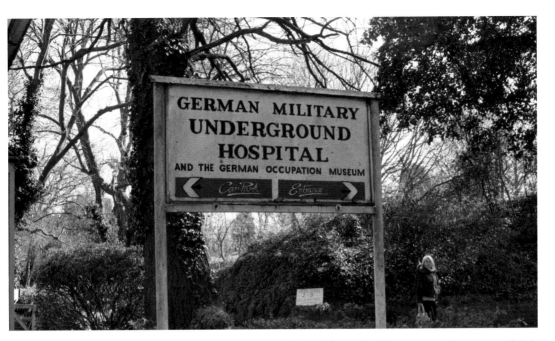

The Underground Hospital, or gas chamber, to be fed from the SS concentration camp of Sylt on Alderney.

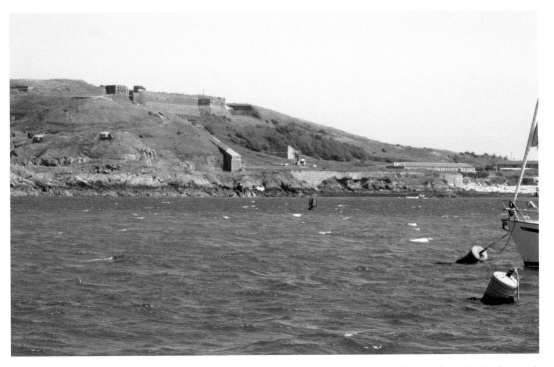

Fort Albert in the background. The SS disposed of the bodies by burying them at low tide in the sand, or throwing them off the cliff. Fort Albert is now a key tourist attraction.

Approach to Braye Harbour and gun emplacements.

Alderney Court.

Camp was strangulation. Many were also shot. For example, there were three extremely sick Russians who were left to lie in the camp for several days, during which time they were given nothing at all to eat. And then an SS officer gave an order to carry them out of the camp to the gate. He shot them there. He explained to us that he did it because these men were very sick and they would infect the whole camp with their illness. I pointed this man out after the war, but he walks around today a free man...

He continues:

We were decimated on Alderney, that about 9 months after we arrived there, five hundred fresh ones were brought in because so many of us were either dead or sick. Half of us, fifty per cent, were killed.

Wernegau commented to Steckoll that he had always hoped that justice would be meted out to the SS men on Alderney at the end of the war, but he says,

In Germany practically nothing happened to them. Those who killed 100,000 in Auschwitz, what did they get? They walked free for many long years, then they got one year and then were almost immediately freed by an amnesty, and they sit outside, free. We don't like this at all. We want justice.'[13]

One of Steckoll's former prisoner interviewees describes Alderney in 1943:

There was nothing in the fields, nothing at all. It was a kind of Devil's Island, even worse than Devil's Island. There was barbed wire everywhere, around every road, big and small. And the signs 'Achtung Minen', everywhere. So, if you left the road and went into a field, as happened in many cases, you could get blown up as happened many times with rabbits.

Alderney was liberated by around 200 British troops on 16 May 1945. They found the graves and burial pits of SS victims on Longis Common. Some of the graves contained two or three bodies. There were also two mass graves: one contained eighty-three bodies and the other forty-eight. It would seem the graves contained mainly French Jews and a few Russian dead. The graves were covered over and a memorial erected, which read, 'Here lie forty-eight unknown Soviet Citizens who died during the German Occupation 1941–1945.' There are no firm estimates as to the total number who died of starvation, exhaustion, wounds or were simply murdered in the four camps, but Steckoll believes that the figures were in the region of 4,000. He quotes the Society of Former Prisoners of Alderney, who were unable to provide figures for the Sylt concentration camp but from the other three camps, 3,000 Russians, 220 Jews and North Africans in total perished. Steckoll, using Red Cross figures, allows at least another 750 Sylt prisoners who either died or were murdered. The lack of graves to match the numbers is accounted for by the

large number of corpses that were dumped in the sea. A Spanish slave worker, John Dalmau, wrote a short and disturbing account of his time on Alderney. He says that he was sent to maintain the installations at Braye Harbour, which today is a quiet, peaceful place that is still overlooked by the German fortifications at Fort Albert situated at the end of the nearby bay. Dalmau tells us that he and a fellow prisoner, Vidal,

> were sent to Fort Albert to help in the construction of an observation post. Some excavation was necessary and political prisoners were put to do this work. During the first morning two of the prisoners collapsed where they stood and to my horror they were thrown over the cliff into the sea. In the afternoon seven more went the same way. Throwing men over the cliff became the standard way of getting rid of exhausted workers. One day at the beginning of April, when

Channel Islands: Alderney street gate by St Annes church.

the non-arrival of a convoy made the Germans a little more bad-tempered than usual, 50 of the slave workers were shot and thrown over the cliff. Some of the men were not dead, but to make sure they did not survive stones were tied to their feet before they were thrown over. The mass murder system was repeated seven times before the observation post was finished.[14]

It is clear that from what Dalmau describes there could not be any accurate record of the numbers who perished. Even more disturbing in the context of the scenic, peaceful harbour of today is what he observed when the anti-submarine boom at Braye Harbour became entangled:

A diving boat was sent to the foot of Fort Albert. Its crew comprised a French diver, two more Frenchmen, Vidal and myself as pump operators, and the Hafenmeister (Harbour-master) to direct the task. After the boat had been anchored a short distance from the cliff the diver went down. A few seconds after the diver had reached the bottom several sharp pulls were felt by Vidal, who was paying out the rope and air tube. He began to pull on the rope and air pipe but after taking in four five feet he was unable to get any more aboard. Meanwhile the sharp pulls continued every few seconds. Then they stopped altogether. Vidal let the rope go slack and gave two sharp pulls but there was no reply. Something had gone wrong. That was apparent. The Hafenmeister ordered me to investigate. Thinking that the trouble might be a big octopus I decided to take my own knife, long, sharp and pointed, discarding the diver's weapon, which was short and broad. Vidal and one of the Frenchmen helped me into another diving suit, and the Hafenmeister himself placed the helmet on my shoulders. After the window had been closed I went down. I sank slowly to the bottom. Soon I began to see the spider net that was the submarine boom and, following the air pipe used by the French diver, reached him in a short while. It was not an octopus holding him but the crossing of two cables of the net. The man was alive but unconscious. I pushed his helmet down to free him from the cables and then pulled his lifeline twice. While the crew pulled the unconscious diver upwards I lowered myself right to the bottom to carry on with the work on the tangled net. Then a fantastic picture presented itself. Amongst the rocks and seaweed there were skeletons all over the place. Crabs and lobsters were having a feast on the bodies which remained intact. I wanted to be sick. I thought I must be dreaming ... but the sight of the fresher bodies standing, blown with internal gases, showed that I was not. Horribly fascinated, I watched the blown-up bodies moving with the tide in a fantastic *danse macabre* ... A sharp pull on my lifeline brought me back to my senses. I signalled back that I was alright and carried on with my job. I found the tangle. It was a cable caught on a rock. Going round the rock to cut the cable I was suddenly and violently sick. Twisted around the cable was a rope holding one of the bodies down. I cut it adrift, and the body shot upwards to the surface, giving the crew above some idea what I had found.[15]

Dalmau observed a '*danse macabre*' of dead bodies at the foot of Fort Albert (centre distant).

For many Jews, Alderney was their final destination. Some survived by hiding their real identity, while others were betrayed by their comrades. For a full, well-researched work on the fate of the Channel Island Jews, see *The Jews in the Occupied Channel Islands, 1940–45*, by Frederick Cohen, a native of Jersey. Cohen tells us that,

> Transportations of labourers to Alderney began in early 1942. Many of the Jews in the early transportations had been arrested in the Paris area. Together with German political prisoners they laboured at the docks, in building machine shops and in making the Lower Road. These workers were housed in vacated Islanders homes in a wired off section of Newtown. There were frequent deaths of prisoners at work, in the harbour and returning from work.

Considerable information is available on the Jews who were transported from France and imprisoned at Norderney camp from mid-1943. However, as there were fewer survivors, less information is available on the Jewish forced workers in

other Alderney camps. Only a few survivor accounts are available, complemented by various references to Jewish workers in MI19 interrogation reports. Although the exact number of Jews held at the Sylt camp is unknown, the Basilov/Pantcheff report and Pantcheff's own published account provide a few references relating to the period after March 1943 when the camp was under the control of SS. Maj. Pantcheff, a War Office official, who was asked to write a report on the events on the islands at the end of the war, details the feud over authority between the senior Organisation Todt official in Alderney, OT Bauleiter Leo Ackermann 221 and SS Haupstrumführer Maximilian List, senior officer at the Sylt camp. Ackermann, although well known for his brutal treatment of OT prisoners, complained to Island Commandant Zuske about the way the SS 'beat their [Sylt] prisoners' while working on the Organisation Todt work sites 'so that their capacity for work might be adversely affected'. Pantcheff wrote,

> [Ackermann] then protested in writing to Fortress Engineer Staff, who referred the protest back to the SS. One of the beaten prisoners had been a Jew and so Ackermann now found himself the object of a counter complaint by the SS that he was soft on Jews. He had the good fortune to have this firmly resisted by the senior OT engineer in the Cherbourg *Oberbauleitung* and the matter was not proceeded with.[16]

There are a number of Public Record Office and Moscow Archive reports that give us an idea of who belonged where in the Alderney camps. One contains a report on the interrogation of two Guernsey men who had worked in Alderney. They stated that Helgoland was the main camp for Jewish workers. An MI19 interrogation report on interviews with three Russian OT workers also stated that

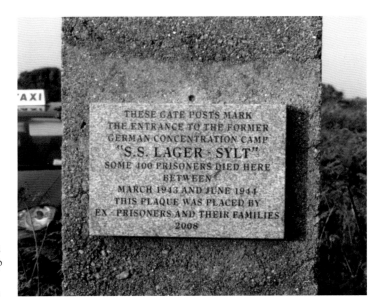

THESE GATE POSTS MARK
THE ENTRANCE TO THE FORMER
GERMAN CONCENTRATION CAMP
"S.S. LAGER - SYLT"
SOME 400 PRISONERS DIED HERE
BETWEEN
MARCH 1943 AND JUNE 1944
THIS PLAQUE WAS PLACED BY
EX - PRISONERS AND THEIR FAMILIES
2008

A memorial placed on the gates of Sylt Camp by ex-prisoners and their families in 2008.

Jews were held at Helgoland before being transferred to Norderney in February 1944. However, while there may well have been individual Jewish prisoners in the camp, it is unlikely that it was specifically a Jewish camp.

Pantcheff noted,

> During the second half of 1942 and the beginning of 1943 the *Bauleiter,* head of building works, was Johann Buthmann ... After two brief periods between March and September 1943 the post was held by Leo Ackermann until the final withdrawal of the OT in summer 1944.[17]

Wherever there is seemingly endless cruelty, there are glimmers of good. Both Kondakov and a post war report comment that, strictly against orders, some German soldiers gave food to the Russians: 'there were Germans, soldiers and officers among them, who secretly gave our countrymen pieces or left-overs...'

However, others enjoyed tormenting the prisoners. The following is an article from *The Independent,* written by John Crosland after a number of Public Record Office files were opened to the public:

> Alderney's losses and profit under Nazi rule
> Files reveal brutality and tales of collaboration
> John Crossland
> Wednesday 20 November 1996

> Details of the German occupation of the Channel Islands were disclosed yesterday, revealing evidence of islanders profiting from their neighbours' misery and the cruelty of the only concentration camp ever operated on British soil.
>
> The last tranche of Channel Island documents, released yesterday at the Public Record Office, throw a harsh light on what the Germans called 'the model occupation'. The files are largely transcripts of interrogations of escapees undertaken by MI19, the intelligence body charged with building up a picture of enemy resources and morale. They give lists of collaborators and 'Jerrybags' – island women who slept with German soldiers and frequently bore their children.
>
> The files also provide the fullest picture yet of the horrors of the Alderney camps, where slave workers – mostly Russian – were starved and beaten to death in the sealed-off island. The papers outline a sickening catalogue of ill treatment, including SS guards using their bloodhounds to hunt the prisoners across the 'deadline' so that they would be shot 'while attempting to escape'.
>
> Of the 1,600 Russian prisoners brought to the island – which was abandoned by the British after the Germans took France – in 1942 to work as forced labourers building fortifications for the Germans, at least half starved or were beaten to death according to MI19.
>
> Too undernourished and exhausted to work efficiently, these men were mercilessly beaten by the German guard and frequently when they were too weak after a beating to stand up, they were clubbed to death or finished off with

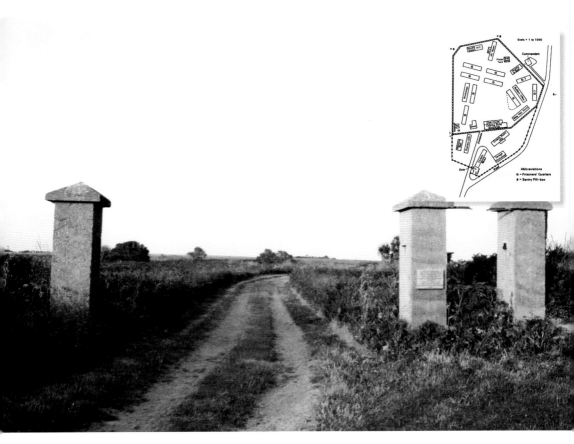

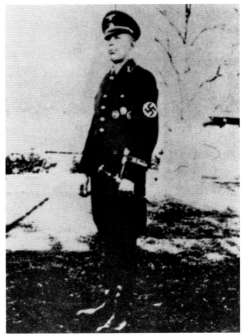

Above: The gates to Sylt Concentration Camp, the site of atrocities. A British government report tells us that a prisoner was hanged and then crucified on the same gate. His body was left hanging on the gate for five days as a warning.

Inset: Diagram of Sylt SS Concentration Camp.

Right: Max Liszt, Commandant of Sylt. After the Second World War, a court-martial case was prepared against Liszt, citing atrocities on Alderney. However, he did not stand trial, and is believed to have lived near Hamburg until his death in the 1980s.

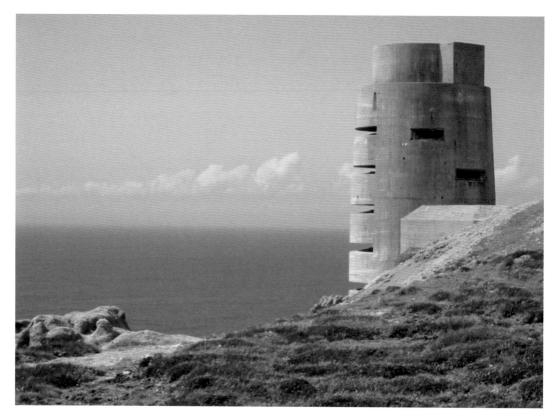

German Second World War Towers, Jersey.

a knife,' one report said. The most notorious of the camps on the island was the SYLT camp for political prisoners including Russian 'defaulters'. The MI19 report said: 'One such was crucified on the camp gates, naked and in midwinter. The German SS guards threw buckets of cold water over him all night until he was finally dead ... Another was caught by bloodhounds when attempting to stow away to the mainland. He was hanged and then crucified to the same gate. His body was left hanging on the gate for five days as a warning.'

The brutality of the Alderney SS regime is further illustrated by Georgi Kondakov, a Russian slave labourer on Alderney who wrote a series of letters recalling his experiences.[18] Interestingly, when he and a large number of other Russian captives arrived on Alderney, he says they became the property of a 'firm'. His firm was 'Strassenbau A. G.' He was about to begin what he calls '14 months of terrible forced labour, constant starvation, and threat of death.' One of his jobs was to make a road up to the eastern, rocky side of Fort Albert.

Steckoll reports the death of a German prisoner, Willie, a camp trustee, who escaped from the Sylt camp; his subsequent death at the hands of the SS and the route he took is still traceable. I followed the route on a quiet, warm Saturday

evening in July when St Anne was at peace, in contrast to the violent end that Willie suffered. Steckoll writes:

> For many years it was believed that this man [Willie] was a Sylt prisoner who had himself been a former member of the Gestapo … Major Pantcheff, in 1945, obtained full details of this incident. Willie, on escaping, hid for two days in the belfry of the church in St Anne, where he was discovered after the SS had turned the Island upside down in their manhunt … he had been dragged out into the churchyard and shot at. Two bullets hit him in the leg as the terrified prisoner kept running up the path between the gravestones. Then one hundred SS men beat him with their rifles and pistols. Since they were standing on both sides of the path the SS could not shoot him for fear of hitting their own comrades. Willie succeeded in making it out of the churchyard and across the cobbled street beyond. Bleeding profusely, he held on to the railings which stood outside the Courthouse in those days. It was at this moment that a Wehrmacht officer pulled up in his car and got out to enter the office. The wounded prisoner, realizing that he was only a whisper away from death, desperately appealed to this officer: 'Herr Hauptman, please save my life.' 'Get the hell out of my way,' was the reply he received and,

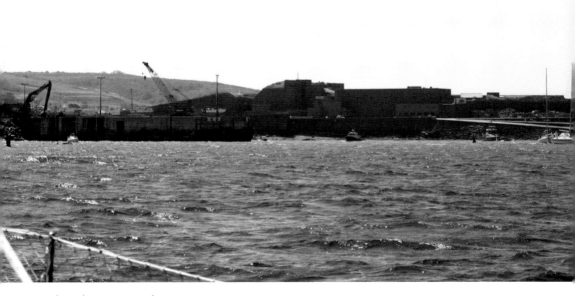

Modern-day Braye Harbour.

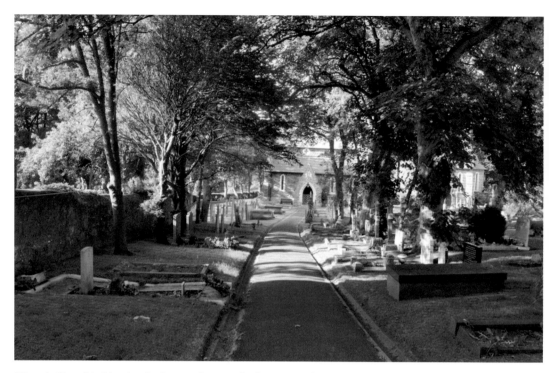

'Two bullets hit him in the leg as the terrified prisoner kept running up the path between the gravestones.' St Anne's churchyard.

The railings opposite the church where Willie pleaded for his life and was shot by the SS.

apart from the screams and shouts of the SS men who then surrounded him, those were the last words that Willie heard. The SS guards began systematically to beat him with their rifle butts, before he was shot in the head.[19]

The States (Alderney's governing body) decline to commemorate the sites of four labour camps. Local historian Colin Partridge feels this may be due to the locals' desire to dissociate themselves from the accusations of collaboration. A faded memorial plate, tucked away behind the island's parish church, vaguely mentions forty-five Soviet citizens who died on Alderney in 1940–45, without saying how they died and why. Colin Partridge is convinced that a decent memorial must be built on Alderney. He and a group of enthusiasts have managed to establish the names of all 460 people who perished in the island's four camps. To begin with, they are now planning to unveil a memorial plate with 460 names on it.[20]

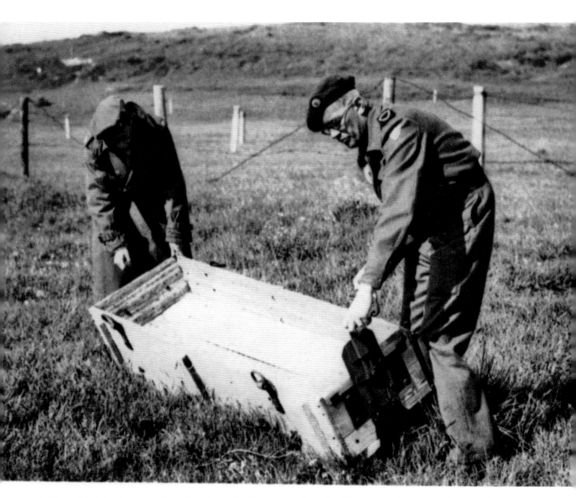

Coffin with false bottom found on Longis Common after the liberation. It was used many times to transport bodies to mass graves.

Victoria Street, Alderney, 2013.

3

Jersey and Guernsey Dealing with History

History can be constructed in a number of ways, as much by what is not remembered as by what is. Despite their proximity, Jersey and Guernsey dealt with occupation in different ways. Similarly, in the twenty-first century, the events of the Second World War are remembered and portrayed differently. Jersey has built up a substantial tourist trail based on its occupation history. Since the mid-1990s, when questions regarding the nature of the occupation became too difficult to simply ignore, both islands dealt with the 'problem' in their own way. The Jersey occupation trail became littered with memorials to resistance heroes, with particular emphasis on the liberation itself. One of the reasons I felt drawn to look at the Channel Island occupation for a second time was that, having completed my doctorate in how Germany had changed the history of the Second World War, I wanted to see if the Channel Islands' experience had been rewritten or changed to suit modern politics and the tourist industry. Modern Germany more or less teaches that Germany was taken over by a band of Austrian, Nazi lunatics who drew the unwilling German people into a futile war – a war that was to end up punishing the German people, because the Allies simply did not understand the reality of what had happened. So good has been the reassessment of history and its propagation that in a survey several years ago, it became clear that a majority of Polish students questioned believed that it was Poland that had started the Second World War. Coming back to the Channel Islands, several years after research for my Master's thesis, I was interested to note that a recent (2012) PhD student, Daniel Travers, had included the Channel Islands dealing with remembrance.[21] He notes that we as a country all seek a myth that gives us a 'glorious past' and preserving this past has meant 'marginalising negative and tangential aspects of the war that did not or do not fit.'

Travers, in keeping with the differing style of war tourism on Jersey and Guernsey, makes a telling observation as to why he specifically concentrated on Jersey:

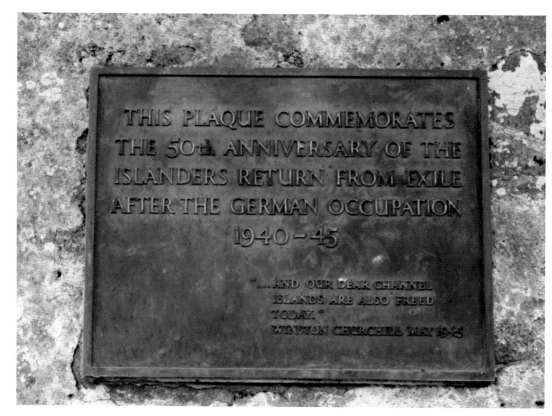

Plaque: return to Alderney.

When research started on this project, it was understood to include all of the Channel Islands, rather than just its largest and most populous. This, however, presented problems with the simple scale of the information available from the Channel Islands and the differences between each island. While Jersey is now much more open about its occupation past, other islands are less keen to publically air their divisive history. Gillian Carr has written about 'the politics of forgetting' in Alderney, arguing that the island's small resident population has been unwilling to face the reality of the island's past. They also do not celebrate Liberation Day in Alderney, preferring to mark 'Homecoming Day' on 15 December – the day when many islanders returned after the occupation – as their day of national remembrance. Carr has also shown that Guernsey, as of 2010, has not erected a memorial to evacuees or political prisoners, which have now been part of Jersey's memorialization for several years. A memorial for sixteen deportees who died has only just been constructed. Though participating in the discussion around occupation which reached its peak in the 1990s, Guernsey's residents have been significantly slower to memorialize some of the more negative aspects of their wartime experience. As a result … Guernsey will provide a comparison for the island of Jersey,

which has developed its occupation heritage, in part, as a response to the lack of acknowledgement in the rest of the Channel Islands. The reluctance of other Channel Islands to fully explore their occupation past has also affected the availability of sources.

Travers mentions that documents in government departments he was given access to on Jersey were denied him in Guernsey. Thus he concluded:

For decades, Channel Island remembrance was forced into close association with the Churchillian paradigm – the notion that islanders behaved with steadfast Britishness in the face of the Nazi enemy. By the 1990s, however, hard hitting questions had started to be asked, forcing Jersey's occupation survivors and younger citizens alike to look introspectively at the islands commemoration and celebration of the Second World War. The mid 1990s saw an explosion of literature on the topic of occupation, which ultimately impacted the direction of heritage in the island. Though a number of tributes to some of the more negative aspects of occupation have been erected since 1990 – to deportations, slave workers, and Jewish victims – changes to some aspects of the traditional remembrance are still fiercely challenged. Liberation Day, for example, has been used as a device to seamlessly connect the island's Second World War experience to glorious British victory, despite Jersey having little part in it. It has traditionally been a day for islanders to bask in 'British' commemorative tropes while re-affirming allegiance to the crown in a festival of celebration. Any attempts to make this day more forward looking or abstract have come at the cost of considerable controversy. Despite now championing (in comparison to other Channel Islands) the most

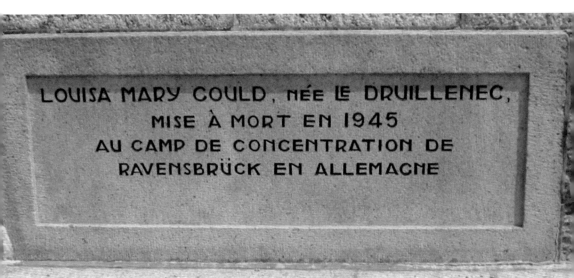

Plaque, St Ouen: Louisa May Gould died in 1945 in Ravensbruck Concentration Camp.

tangential wartime history within the British Isles, Jersey's citizenry still need a tangible connection to the British War story, and the liberation celebrations provide this.

As Travers observes:

Within living history, a picture of the past is deliberately constructed and then passed off as being 'how it *really* happened'. Steven Conn has written that museums no longer need objects to be successful. Some museums still use the objects as a device with which to tell a story, others prefer to let objects become secondary to transmission of message, using other didactic devices, such as interactive boards and audio-visual presentations. Many museums in the twenty-first century have shifted from emphasis on growth, care, and study of its collections to an outward focus on service, education and cultural transmission.

He continues:

The narrative focused on islanders behaving with steadfast Britishness in the face of the enemy. This narrative, which heavily favoured events such as the islands' liberation while minimising some of the more divisive stories, existed for several decades. In fact it was not until the late 1980s and early 1990s that historical interest in occupation peaked – both in the islands and on the British mainland, and Channel Islanders were forced to look introspectively at their society and wartime history. This was helped along by the opening of archival sources about the occupation, and by the publication of certain works which, though causing sensation on the islands helped to create discussion about the nature of occupation. As a result, the Channel Islands have slowly begun to part with their comfortable narrative, publically commemorating aspects of the occupation which were particularly traumatic and tangential. Though this has been the case in all of the Channel Islands, it is Jersey where it has had the most impact. As Gillian Carr has argued, Jersey has experienced a 'rapid increase in memorialisation' in the last decade. This, it seems, is due to a feeling of moral necessity on the part of the islanders, a sense which has been created out of a new understanding of the island's war history. There is now a desire to memorialise, in a tangible way, aspects of the Second World War which have until recently had no place in the public sphere except in the minds of those who survived it. This coincides with a new trend in Britain, one which seeks to overturn the myth of the 'uncommemorated generation' by erecting permanent memorials to people and groups which have until now not been recognised in this way. As a result, since the celebration of the end of the war in 1995, a transition has occurred in Jersey's commemorations, memorials, and museums, in order to include these stories. This has resulted in the development of a number of events, memorials, and plaques – 'sites of memory' which break with the traditional British wartime narrative by highlighting some of the more tangential aspects of the island's war. Jersey's new

Jersey Memorial on the quay.

heritage direction has the added benefit of allowing the island to break with the traditional Churchillian paradigm helping to distinguish it from Britain and from its Channel Island neighbours, while efforts have also been made, by the island's 'heritage experts' to use the island's occupation past for something more forward looking; promoting reconciliation, education, and defeating intolerance.

Though it has fully incorporated the negative (and tragic) elements of its war experience into its memorialisation, some subjects remain controversial. Liberation Day, a date which commemorates liberation from German occupation, has traditionally served as a way for the island to connect its wartime experience to the British traditional wartime narrative. Recent proposals to change the nature of the celebrations from celebration of the act of liberation to a more forward-looking stance of growth, reconciliation, and peace have, at best, met with a lukewarm response. At worst, they have been heavily criticised for not commemorating the true meaning of Liberation Day. Jersey's Liberation Day points to the need for the continuance of tradition and a day for the positive remembrance of Jersey's role in the Second World War.

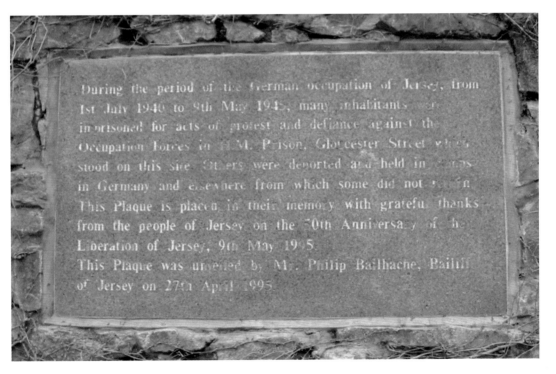

Above: Plaque, Jersey.

Opposite page: Guernsey Memorial.

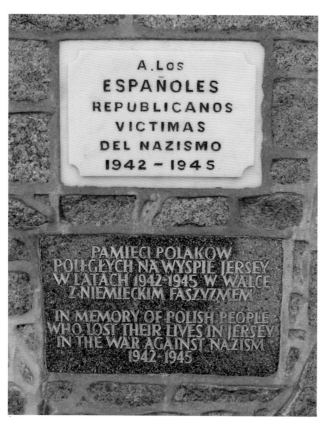

A.LOS
ESPAÑOLES
REPUBLICANOS
VICTIMAS
DEL NAZISMO
1942 – 1945

PAMIĘCI POLAKÓW
POLEGŁYCH NA WYSPIE JERSEY
W LATACH 1942-1945 W WALCE
Z NIEMIECKIM FASZYZMEM

IN MEMORY OF POLISH PEOPLE
WHO LOST THEIR LIVES IN JERSEY
IN THE WAR AGAINST NAZISM
1942-1945

Right: Plaques dedicated to Spanish and Polish victims who lost their lives in Jersey during the Second World War.

Below: Plaque dedicated to American escapees.

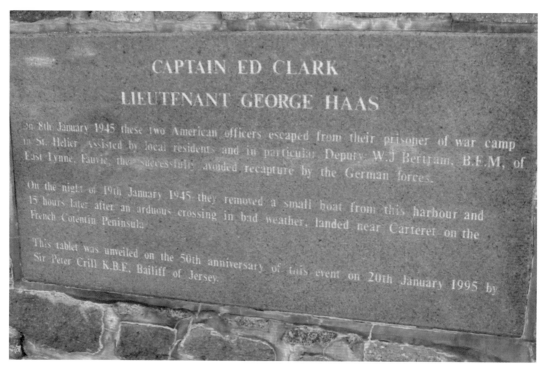

CAPTAIN ED CLARK

LIEUTENANT GEORGE HAAS

On 8th January 1945 these two American officers escaped from their prisoner of war camp in St. Helier. Assisted by local residents and in particular Deputy W.J Bertram, B.E.M, of East Lynne, Fauvic they successfully avoided recapture by the German forces.

On the night of 19th January 1945 they removed a small boat from this harbour and 15 hours later after an arduous crossing in bad weather, landed near Carteret on the French Cotentin Peninsula.

This tablet was unveiled on the 50th anniversary of this event on 20th January 1995 by Sir Peter Crill K.B.E, Bailiff of Jersey.

Right: Liberation Monument, Guernsey.

Below: St Helier Marina, Jersey: site of memorials.

4

Underground Hospitals or Extermination Chambers?

It has been suggested by Tom Freeman-Keel, a respected writer on the subject of wartime events in the Channel Islands, that not only was the invasion itself a model for the invasion of Britain, an idea with which there is much agreement, but that the islands (Guernsey and Jersey in particular) were to be the scene of genocide. After all, there were 450,000 British Jews and 2,820 eminent persons listed by the Germans that would need to disappear quietly, and away from Britain's resident population. The suggestion is that the underground hospitals on Guernsey and Jersey, both of which are key tourist sites today, were designed for conversion into gas chambers. A chapter of his book, *From Auschwitz and Beyond*,[22] is devoted to proving the idea. His evidence is convincing; the pieces are put together in a manner that fit. In recollections titled *A Peep Behind the Screens*, a Guernsey nurse called Ozanne Beryl wrote:

> I had to pass along the road where the Germans were building their underground tunnels. When we saw all the work going on there, once again the rumours were rife. There was talk of gas-chambers … Knowing even the troops were getting short of food, were they that desperate? Did they intend reducing the population?[23]

Freeman-Keel correctly observes that the threat to the Germans from enemy British aircraft once Britain had been defeated would make the transportation of Jews from mainland England straightforward. He describes the evolution of the Polish extermination camps, how inadequacies were remedied and how, by the beginning of January 1942, the architects taken on by Himmler, in conjunction with the crematoria manufacturing company Topf & Sons, had solved the problems associated with mass extermination. He argues that the 'hospitals' had been built as efficient functioning replicas of the gas chambers and crematoria at Auschwitz-Birkenau. Freeman-Keel argues that the chambers (described today as 'wards') in the hospitals would have been used for storing the possessions of the victims to be gassed. They could also have

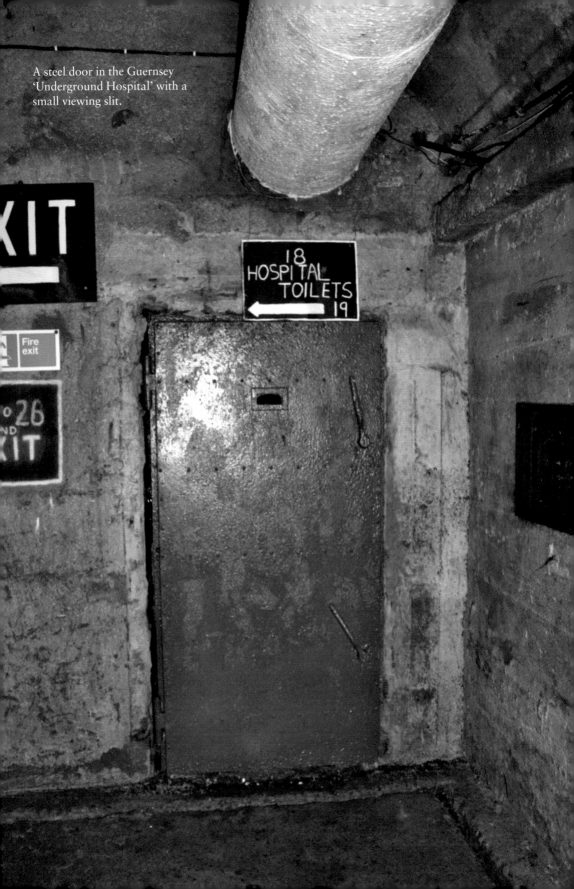

A steel door in the Guernsey 'Underground Hospital' with a small viewing slit.

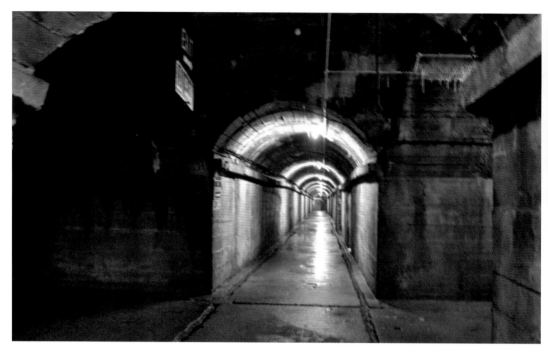

One of the Guernsey Underground Hospital tunnels. The 'wards' run to the right down the length of the tunnel.

The entrance to the sparse, cold and damp Guernsey tunnel complex.

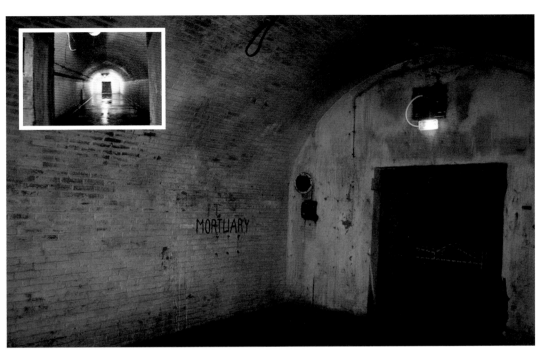

Guernsey Underground Hospital mortuary.

Inset: One of the Guernsey underground hospital 'wards.' Note the steel doors at the far end.

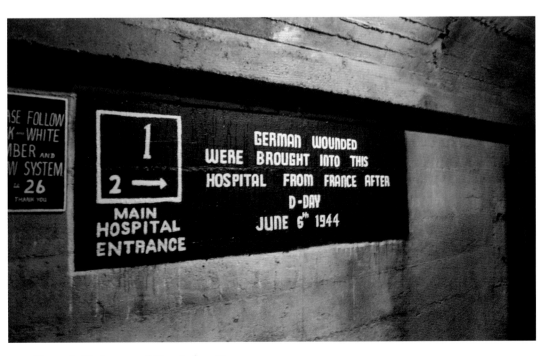

Plaque in Underground Hospital on Guernsey.

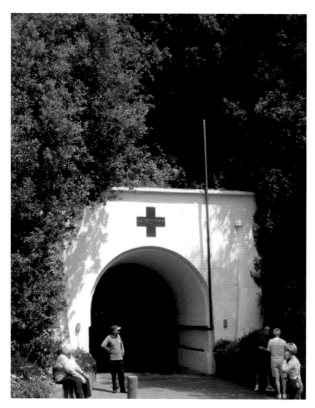

Left: Underground Hospital entrance.

Below: Jersey 'Underground Hospital' steel doors.

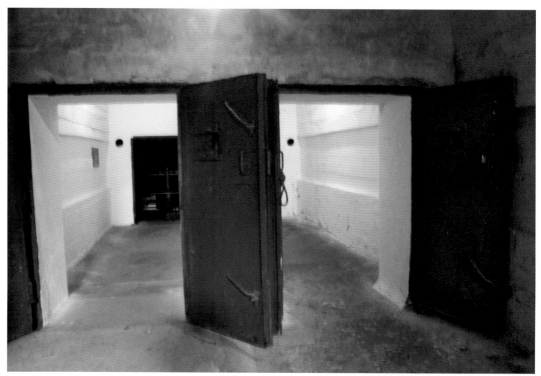

been used for storing bodies awaiting cremation. He demonstrates with reference to Auschwitz-Birkenau that certain elements were needed for the successful operation of mass murder by gas. These included water for the washing down process with regards to the cyanide. The Guernsey complex has a suitably situated well.

> The wards have drainage channels and narrow gauge railway lines are still to be seen and, as with the Guernsey construction, floors slope towards an entrance – yet further proof of the recognition that a washing down process would have been essential.[24]

Freeman-Keel summarises the similarities between the Birkenau crematoria and the Channel Islands tunnels as follows:

1. The tunnels and the Crematoria were all fitted with gas-proof doors.
2. Escape shafts of similar size existed in both Auschwitz and the Channel Islands. (They were used in Birkenau for inserting the hydrogen cyanide pellets.)
3. Chutes were incorporated into the design of the Auschwitz/Birkenau gas-chambers. A chute still exists in the Jersey 'underground hospital'.
4. A 'ventilation' system was installed in the gassing areas of Auschwitz/Birkenau. A ventilation system exists in the Jersey tunnelling.
5. Artificial reservoirs were built within the Channel Islands 'underground hospitals'. A good water supply was used and was available at the Auschwitz/Birkenau camps.
6. Electricity is an important factor in the operation of the 'killing machine'. It was freely available both in Auschwitz and in the Channel Islands.
7. Staircases are provided in the Auschwitz Crematoria and also in the Jersey and Guernsey 'underground hospitals'.
8. Narrow gauge rail tracking was installed in Auschwitz/Birkenau for transportation of bodies. Similar track was installed, and can still be seen, in the Jersey tunnelling.
9. On 18th September 1942 two Heilman & Littman steam engines arrived to power the compressors for the excavation machinery required for the tunnelling and by November a wooden structure was being built in preparation for the construction of 50' chimney. The design and measurements of this chimney were identical to those built in Birkenau for the new Crematoria.

The author's summary points out that, allowing for the size of the chambers and the numbers, 'the mass murder of Britain's half million Jews and anti-Nazis would have been accomplished in less than a year'.[25]

5

The Nature of Resistance and the Channel Islands

In *The Collaborator: The Trial and Execution of Robert Brasiltach*, which deals with a prominent Vichy France incident of collaboration, Alice Kaplan makes the important point in her introduction that 'history is not only the accumulation of facts, the recovery of documents; it is also the understanding of passions.'[26] This is true of the events in Jersey, Guernsey and Alderney. There was a series of events that even today raises high emotions as to their culpability in their five-year relationship with the German occupiers. What some see as a means of pacifying the occupiers, others regard as evidence of collaboration. The early formal guidebook view reads,

> Relations between the civilian population and the occupying forces seem to have been on a more rigid basis in Jersey than elsewhere, with less bloody-mindedness, with less fraternisation.

But equally, the acting lieutenants of Jersey and Guernsey were now the Bailiffs, Alexander Coutanche and Victor Gosselin Carey respectively. Both have been the subject of extreme controversy.[27] The Cruickshank official history demonstrates an understanding of the difficult roles they were forced to play, always looking to protect the welfare of the majority while implementing controversial legislation and policies. Another commentator, Henry Myhill, observes of their activities:

> It involved not only constant wariness in dealing with the occupying authorities, but, more bitterly still, some misunderstandings with the civilian populations whom they were working hard to protect.

Not all are of the same opinion. Solomon Steckol, using documents that had previously been presumed destroyed, came to a different conclusion when he wrote of the immediate post-war period:

instead of putting Bailiff Victor Carey on trial so that a competent Court of Law could have ruled whether he was guilty or innocent of criminal collaboration with the enemy, he was honoured with a knighthood. All attempts to have a proper and full investigation of the actions of Victor Carey were effectively quashed when he was honoured on 12 December 1945.[28]

Even more extraordinary, Coutanche, who also was knighted, later received a peerage. A *Guardian* article suggested that instead of being knighted, he should have been hanged. This theme of working with occupying forces to protect the native population is certainly not unique to the Channel Islands. In the first days of the Vichy government, Petain claimed exactly the same 'buffer' motive:

> In the beginning, Petain promised to provide France with a shield against the occupant, even though he governed almost entirely on the Germans' sufferance: 'I make to France the gift of my person to attenuate her suffering.'[29]

In his updated book *Petain's Crime*, Paul Webster shows little sympathy with this excuse. He quotes from Petain's radio broadcast six days after his meeting with Hitler, when he made a speech that would later, as Webster observes, justify the charges of high treason against him:

> It is with honour and to maintain French unity a unity of ten centuries in the framework of constructive activity in the new European order that, today, I enter into the way of collaboration … Therefore, in the near future, the burden of sufferings of our country should be eased, the fate of our prisoners improved and the cost of occupation lightened.[30]

Robert Paxton, a leading authority on Vichy France, could be said to be speaking of Channel Island government in his condemnation of what he saw as the reality of the relationship between the Germans and the Vichy French:

> The accepted notion developed after World War II that the Vichy Government has sought to protect a nation of '40 million resisters' from the worst cruelties of the German occupiers. Instead, he showed that the Vichy regime had sought real collaboration with Germany – consistently offering more than the Germans asked, particularly in the area of anti-Semitic policies – to carve out a role for France under Hitler in a future New European Order.[31]

This ideology will appear in the justification originating from the Channel Islands after 1945. The bookshops and libraries of the Channel Islands naturally tend to emphasise the heroic resistance of the islanders under very difficult circumstances, but, over the last fifteen years, deeper enquiries have been launched into the reality of island life during this period. Due to pressure by MPs headed by David Winnick and the All Party Parliamentary War Crimes Group, December 1992 saw the

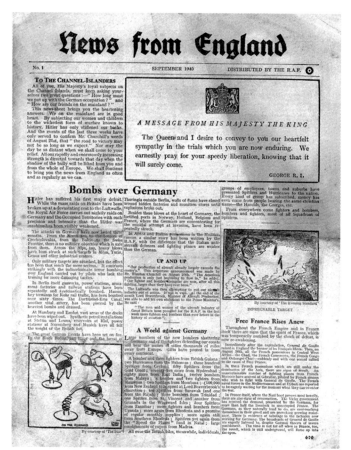

'How long must we put up with the German occupation' and 'How are our friends on the mainland?': *News from England* and a message from HM the King, September 1940.

release of twenty-six out of thirty-three Public Records Office files dealing with the occupation. Even then, sixteen of these twenty-six files had documents removed for reasons given as relating to national security or personal sensitivity. The remainder of the files remain unavailable until 2045. Tom Freeman-Keel has commented that the result of the 'extractions' was, of course, to make the twenty-six files innocuous.[32] But why were seven files withheld, and still withheld, after such a lengthy period? The key players, Coutanche and Carey, have long perished, but Freeman-Keel believes these files are being withheld to protect the families of the Channel Island officials accused of collaboration. He believes the twenty-six files largely relate to the Alderney concentration camp and the 'ill-treatment of prisoners working in Guernsey by Guernsey collaborators, and the alleged too eager collaboration of the Authorities with the German Occupying Forces.' Even so, the files, by the nature of their secrecy, stimulated a renewed interest in the events on the Channel Islands. Sections were blacked out of the files, presumably to protect those still living, but, in Madelaine Bunting's opinion, one major blackout was a reference to islanders working for the occupation forces and wearing Wehrmacht uniforms. In 1991, the Jersey Occupation files were stolen and later returned, leaving the suspicion

that documents had been removed. The Guernsey Occupation documents are still classified until 2045. Because of the involvement of a number of Russian prisoners who were on Alderney, many copy files, which the War Office believed destroyed, and were declassified, appeared in Moscow in May 1993. Furthermore, some other files that were previously believed to have been destroyed found their way to the Holocaust Archives of Yad Vashem in Jerusalem. It is not recorded as to how or with whom they arrived there.

The period saw the keen, unprompted implementation by the still in situ Channel island governments of the anti-Jewish regulations and the deportation of the island Jews. The governments seemed to require little prompting from the occupation forces. The German and Channel Island governments undoubtedly worked closely together. The only areas of dispute are based on justification for their co-operation, and the closeness of that co-operation. Post-war comments included the timeworn phrase that any co-operation was simply to act as a buffer between the Germans and the civilian population. There were undoubtedly a large number of men who had left the islands prior to the occupation to fight with the British forces. A high proportion of the remaining wives and girlfriends developed relationships with German soldiers, some bearing children, and some subsequently leaving the islands to marry. These women were subsequently derided as 'Jerrybags'. Indeed, War Office document 19912114 observes from a report smuggled out of Jersey during the occupation:

> Jersey-born women have been prostituting themselves with the Germans in the most shameless manner. There are quite a considerable number of these women all over the island. Many of them are the wives and daughters of men who are now fighting in the British Armed Forces.[33]

Collaboration as a concept does not exist in a black-and-white form – there are differentiations. It tends to be the victors who determine boundaries. Kaplan makes this point in relation to Vichy when she writes,

> For women, at a time when hundreds of thousands of men were gone in work camps or in prisoner-of-war camps, could a relationship with a German soldier remain a private affair, or was it an act of collaboration? Was the personal always political? On the question of food, could one give into black market co-operation with Germans in order to eat? Or was black marketeering an act of resistance against the system? Was laughing at the same jokes, crying at the same movie, enjoying the same dancing girls an act of collaboration? In every town in France there were stories of betrayal, accommodation, sainthood, sacrifice, and evil; there was not always agreement on which was which.[34]

In many respects, there is an uncanny similarity between the events of Vichy and the Channel Islands, right through from the unprompted imposition of anti-Semitic legislation, through to the deportation of the native Jewish population. In order to

understand the true implications of the German Occupation, it is helpful to look at the way in which the Germans administered 'racially similar' occupied countries. In doing so, it is important to be aware of how the populations reacted, how they behaved within the areas of everyday work, and social functioning. Vichy France, because of both its proximity and autonomy, provides an interesting cross-reference point. Occupations such as those in Poland and Russia are not relevant, in that the Nazis regarded the population as *Untermenschen*, or sub-human, and these occupations were brutal in the extreme, but this is not to say that even in Poland collaboration was not extensive. At the same time, there are some fundamental questions that need to be asked:

> What was collaboration? Who in France, Belgium, the Netherlands, and Italy, helped the Nazis achieve their goals and why? What was the resistance? What did it mean to resist and how far can we still give credit to the heroic if self-serving tales that came out of the war in much of Western Europe and served as the moral cement with which post-war democracies reconstructed themselves.[35]

In examining the Channel Island Occupation and the evidence relating to collaboration, the events need fitting into a framework of collaboration in relation to key occupied European countries. Of close and particular relevance is reference to Vichy France in order to set a framework of theory and reality of what exactly it meant at a human level to have one's country invaded, and the subsequent options of passive existence, collaboration in the Petain sense of the word, or resistance. Why was there collaboration both in the Channel Islands and the occupied European countries? Could it have been because the population and the civil servants in 1940 believed that the Germans were on the winning side and would ultimately achieve victory? If so, is there a discernible change in the collaboration picture post-Stalingrad in 1943? Robert Paxton looks to the winter of 1942/43, with El Alamein as the turning point, and significantly titles one of his chapters 'Collaboration: 1942–1944'. (*Vichy France: Old Guard and New Order 1940–1944 Between Liberation and Revolution*).

Definitions of resistance vary. One man's petty criminal is a post-war resister. Did stealing food, money or bicycles from the occupiers make one a resister? Were the resisters punished or allowed to go on their way? This is important in indicating the likely effects of not implementing Nazi policy in the Channel Islands against the experience of elsewhere. It is interesting to look at the structure of the German occupation in terms of administration, of the role and attitude of the indigenous government, and the way it interacted with the occupiers at a governmental and social level. Sources looked at include diaries and the main secondary sources, which tend to argue the collaborationist or collaboration theory, and make an argument based on the evidence and with reference to any similarities in occupied western Europe. The key theme is whether the populations actually collaborated, and if so to what extent. How does the collaboration fall into the Paxton/Rings categories? If there was widespread collaboration, was it justified? And can one justify collaboration if it allows one to survive? After all, the British had completely

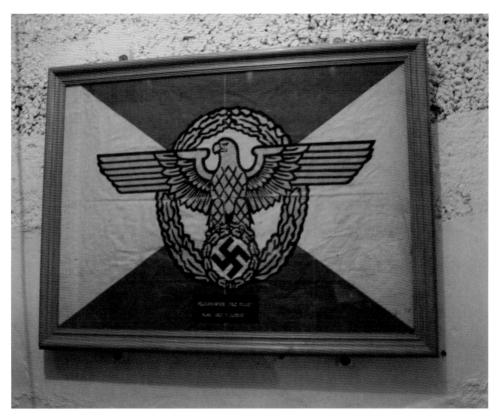

The new Guernsey flag from 1940.

abandoned the islanders to the Germans despite a connection reaching back to AD 933 when the islands became a part of the Duchy of Normandy. Centuries of loyalty meant little when strategic importance was the measure. Perhaps the islanders simply felt abandoned and went into survival mode? Madeleine Bunting acknowledges that memoirs are heavily biased towards stories of 'hardship, shortages, queues, and drudgery', but 'the daily life in the Occupation was riddled with moral dilemmas which every islander, regardless of age or social status, had to confront.' Was there a threat of repression or persecution? Was there any resistance, and if not, why not? If so, what form did it take? Could it really be regarded as 'resistance'?

Looking at the pattern and nature of resistance, if it really existed, is what comes at the end of the story. Usually, retribution is the reverse side of collaboration. Retribution was common in nearby France and Vichy France. By its nature, retribution is almost certainly related to the numbers who were for versus against the occupying force. German sources, of which there are many, letters and diaries, allow us to determine whether collaborators were in the minority or majority and the conception of contemporary controversial events. Since the release of British Government papers and the discovery of documents previously believed to be lost

or destroyed in the Yad Vashem Holocaust archives in Jerusalem, some damning revelations concerning Guernsey Bailiff Victor Carey and his role in the persecution of the Jewish population, covering the period from 1940 until 22 October 1942, have come to light. The War Office documents released under the thirty-year rule reveal a strong belief in traitorous governmental activity and collaboration during the period. Many documents in the Guernsey archives remain sealed until 2045. By comparing the use of material and the way in which it has been interpreted, it is clear that a gradual rewriting of history is taking place.

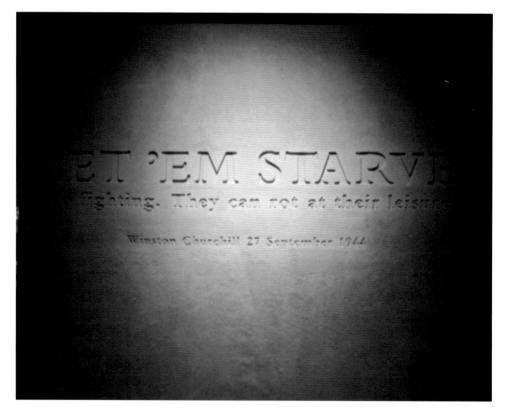

Jersey War Museum exhibit: 'Let 'em Starve. No fighting. They can rot at their leisure.' A statement made on 27 September 1944 by Churchill when he heard that the occupants of the Channel Islands were starving. He may have been referring to the islanders, but the official explanation is that he said it of the starving German soldiers.

6

The Channel Islands and the Jews

One of the main reasons why events on the islands are of wider interest than just to the island populations themselves and curious historians is that the occupation was seen as a model for the occupation of the rest of Britain. To observe the events relating to the Jews who found themselves on the islands alongside the occupiers is probably a lesson as to what would have happened had Britain been invaded. It is likely that the Westminster government would have been left largely in place, although members would have been subject to German approval, and that laws against Jews and businesses run by Jews implemented in a number of the occupied European countries would have been put in place. There is significant evidence that the two massive structures on Jersey and Guernsey, referred to as underground hospitals, now major tourist sights, were probably built as extermination centres, most likely for British Jews. Finally, the events on Guernsey and, in particular, Alderney, make it clear that Jewish lives were considered totally expendable. It is important to remember that we are observing the events on the islands with hindsight, and making judgment accordingly. What is clear is that, at the time of the occupation, the German war machine seemed invincible. It is highly likely that government and many islanders thought that the occupation would be permanent. This would explain many of their subsequent actions.

The treatment of the Jewish population is probably one of the most controversial and key areas of the entire occupation, and relates directly to the question of collaboration and the degree thereof. Many of the official Channel Island works dismiss the handing over and deportation of the islands' Jewish occupants (those that had not previously evacuated) as a sad, minor event inflicted by the Nazis, which was much regretted but inevitable. The official Cruickshank *Island History* version simply states,

> The Island authorities could have turned the anti-Jewish laws into a test case. There were few Jews left in the Islands, and little was at stake, except a principle. If the

Islanders had refused to register the legislation it would have been promulgated by decree, but at least they would have made a stand. At what cost we cannot tell ... two Channel Islanders may have been saved ... [the island authorities] could hardly foresee that a matter of academic principle might suddenly become a matter of hard and shameful practice.[36]

In a similarly abbreviated manner, Frank Falla in his 1967 recall of events, to which he was both eyewitness and participant, observes that,

> They [the Germans] had not been long in our island before they started checking up on Jews, but thanks to the evacuation they had little or no satisfaction in this direction. Still hoping, and not to be put off so easily they searched the island records in an effort to dig out any descendants of Jews, but here too they drew a blank.[37]

Much of the surviving documentation and the benefit of time allows much more detailed analyses of the course of events. As already referenced, an extremely well-researched volume, *The Jews in the Channel Islands During the German Occupation, 1940–1945*, by Frederick Cohen, the president of the Jersey Jewish Congregation,[38] published in its latest edition in 2000, identifies the key documents and course of events by use of key primary sources. His work is important in that he identifies a number of his sources as newly discovered. In 1995, he came across 'a dusty cardboard box in the archive of the Greffier of the States of Jersey' with the title, 'Aliens Office, Island of Jersey, Orders relating to Measures against the Jews'. He uses British Military Intelligence reports released by the Public Records Office in 1996, which, as Cohen comments, 'provide useful information on post-war interpretation of the implementation of the anti-Jewish measures in the islands.[39] In 1999, 100 files in the Jersey Law Officers Department came to light relating to the operational relationship between the civilian authorities and the German occupiers on matters from anti-Jewish legislation and policing, to agriculture inquiries ... of and post-war these files, the Jersey Attorney General's file', Jewish Undertakings etc 'provides new insight into the process of the Aryanisation of Jewish businesses and the search for undeclared Jews'. Cohen uses two previously unexamined diaries from the Jersey Aliens Office, which describe the 'process of routing out undeclared Jews'. He also makes use of the same files as Solomon Steckoll, which 'mysteriously' appeared at the Yad Vashem archive in Jerusalem, and had for a long time been presumed, destroyed. These files provide significant information on the implementation of the measures against the Jews in Guernsey. This file contains many papers originating from the Bailiff and Controlling Committee's offices. His examination of the course of events is remarkably detailed, and any objective observations or criticisms limited. Effectively, all action and impetus comes totally from without: the implementation of the discriminatory measures against the Jews remaining in the Channel Islands commenced on Monday 21 October 1940 when the following notice appeared in the *Jersey Evening Post*:

JEWS TO REGISTER

The Bailiff said he had received two Orders from the German authorities, the first relating to measures to be taken for the registration of Jews. This was read by the Attorney-General and on his conclusions was lodged with the Greffe[40] and its promulgation ordered. The Bailiff announced that he had entrusted the Chief Aliens Officer with the registration of the Jews under the Order.

He goes on to explain how a measure to allow the Channel Islands to actively participate in their own little piece of the Holocaust, at a time prior to active enforcement of anti-Jewish measures elsewhere, came about:

The Measures implemented against the Jews of the Channel Islands comprised formal orders originating in Paris. The orders mirrored the pattern of orders and measures against the Jews in France. These orders were subsequently registered in the Royal Courts of Jersey and Guernsey by the civilian authorities under instruction from the occupying German authorities, Dr William Caspar.

Caspar was the head of the German administration. The formal orders originated from Paris and mirrored the orders and measures against the Jews in France. Interestingly, Casper stated, in relation to orders coming from the Military Commander in France, that 'the Chief Administrator for the islands could in theory make exceptions if he felt the orders weren't applicable locally'.

On 8 July 1940, the German commander, Capt. Gussek, after consultation with the Bailiff of Jersey, issued an order that was to form the basis of the legal relations between the civilian authorities and the German occupiers. This stated,

The Civil Government and Courts of the Island will continue to function as heretofore save that all Laws, Ordinances, Regulations and Orders will be submitted to the German Commandant before being enacted ... The Orders of the German Commandant heretofore now and hereafter issued shall in due course be registered in the records of the Island of Jersey, in order that no person may plead ignorance thereof.

The early orders against the Jews were published in the *Jersey Evening Post* and the *Guernsey Evening Press*. The Feldkommandant determined that the later orders were to be registered in the Royal Courts but not advertised in the local newspaper, and registered Jews were to be informed directly of the terms of each order. As an example, Clifford Orange notified the registered Jews of the Sixth Order, recording in the Aliens Office file that 'each registered Jew verbally had his or her attention drawn to the Order'.

The orders and measures imposed on the Jews had a substantial effect on the lives of those who remained in the islands. Some were subjected to closure of their businesses, deprived of the ability to obtain employment or earn a living in any way. They were subject to a curfew, repeated interviews, fear, deportation

and ultimately death. Cohen notes that many of the documents of the civilian authorities and the German occupiers relating to the anti-Jewish measures in the islands are 'lost' or destroyed.

> However what has survived represents a staggering quantity of administrative paperwork considering it concerns so few individuals. Furthermore it vividly illustrates the importance the Germans placed upon rooting out and discriminating against the few Jews even in the Channel Islands.

The assistance received by the German authorities was far from reluctant. The anti-Jewish orders in Jersey, Guernsey and Sark were enforced in the islands under the direction of the ordinary offices of the administrative arm of the German army.

Cohen observes that, in July 1940, the island authorities had little choice other than to accept the German proclamation, if they wished to retain their offices:

> The Orders of the German Commandant heretofore now and hereafter issued shall in due course be registered in the records of the Island of Jersey, in order that no person may plead ignorance thereof.

On Jersey, Bailiff Coutanche referred to this proclamation to justify his relationship with the German administration. Cohen, a person of prominence in Jersey, comments without passing judgement and says that a

> direct consequence of this proclamation was the decision to register the first anti-Jewish Order in the islands' Royal Courts in October 1940 and the subsequent orders were registered following this precedent. Although the authorities had ample evidence that the anti-Jewish orders were cumulatively significantly affecting the lives of the registered Jews it was only when the Eighth Order [the order requiring all Jews to wear a yellow star] was presented to Bailiff Coutanche that he and Attorney-General Aubin seemingly re-examined the moral and legal issues. The evidence indicates a successful appeal to the German administrators against the registration of the Order. There is however no evidence that any further protests were made against the anti-Jewish orders and in Guernsey even the Eighth Order appears to have been registered without objection.

The legitimacy of promulgation in the Royal Courts led to Jewish island residents registering; disaster would follow. The anti-Jewish laws raised little if any protest at all from either the Jersey or Guernsey governments. Cohen cites the only recorded objection to the registration of the first anti-Jewish order. Ambrose Sherwill, the Attorney-General of Guernsey, in his unpublished memoirs, recounted the objection made by Sir Abraham Laine, a Jurat of Guernsey's Royal Court:

> I noted its provisions [from the German command in Paris] which included the required wearing by all Jews of the yellow star of David. It disgusted me and I

visualised Jews being jeered at on Guernsey in the streets, pelted with filth and generally harassed, but I had no premonition of the appalling atrocities which were to be perpetrated on them by the Nazi regime. I made such enquiries as I could and learned, accurately as it turned out, that the few Jews who had settled on Guernsey had all evacuated. In these circumstances, I felt no purpose would be served in ... advising the Royal Court to refuse to register it. If I had, presumably the Germans would have threatened the Royal Court by marching in armed soldiers.

Nevertheless, I still feel shamed that I did not do something by way of protest to the Germans: a vital principle was at stake even if no human being in Guernsey was actually affected. The honour of refusing to concur in registration fell to Sir Abraham Laine who, when called on as a Jurat to vote on the matter, openly and categorically refused his assent and stated his grave objections to such a measure.

No mention of Laine's objection is contained in any of the British Intelligence reports prepared in the early post-liberation period (*see below*) and Laine is listed as one of the Jurats participant in the promulgation of the First Order in the Royal Court of Guernsey on 23 October 1940. Ralph Durand, in a 1946 account of the circumstances surrounding the registration of the First Order, also makes no reference to Laine's objection:

It seems more probable that each member of the Royal Court present at the special sitting considered that to refuse his vote for the registration of the order, however much it offended his conscience and judgement would be futile...

It is the duty of a jurat ... to vote against the registration of any order of which he does not approve. Since it seems incredible that the jurats concerned approved the 'Measures against the Jews' Order it surely follows that they voted for its registration.

The Revd Douglas Ord also initially presumed that all the Jewish residents of Guernsey had left the island before the war, noting in his diary on 24 October 1940, 'thank God the few we had are safely in England.' As attorney-general, Sherwill knew that four Jews were registered in Guernsey and had not all evacuated as he claimed, and even Durand was aware that 'half a dozen people were affected by the Measures against Jews'. Sherwill's account also confuses the terms of the First and Eighth orders. The Eighth Order was the wearing by Jews of the yellow star. Apart from Sherwill's observation, Sir Abraham Laine's objection does not appear anywhere. As Freeman-Keel comments, 'It is regrettable that Sherwill's brief reference, in his otherwise deficient account, remains the sole source on this principled objection.'

Steckoll quotes from Maj. Gen. Count von Schmettow, the German Commander of the Channel Islands, who wrote in a report on the occupation:

Under the control of the military administration the island governments remaining in office were given far-reaching independence and responsibility. All orders and

regulations issued by the Military Commander of occupied France were changed so as to fit the particular conditions of the islands.[41]

By August 1945, such was the discontent on the islands with their own rulers that on Jersey, a petition was sent to the King, listing the civilian authorities registration of the anti-Jewish orders as one of the many points. On 18 June 1945, the Home Secretary wrote to the Bailiff of Jersey detailing the variety of complaints made about the conduct of the island's administration during the recent occupation. Alexander Coutanche, Bailiff of Jersey, responded with the following within a twenty-five page answer:

> The Court had no option but to register this German Order. There was no consternation. The number of persons affected was extremely small and moderation was shown in the execution of the Order. It could be shown that other oppressive measures against the Jews were entirely avoided by proper intervention of the Authorities.

Cohen, quoting from a British Military Intelligence Report[42] dated 17 August 1945, reveals a strong level of distaste for anti-Freemason orders as opposed to the Jewish orders:

> When the Germans proposed to put their anti-Jewish measures into force, no protest whatever was raised by any of the Guernsey Officials, and they hastened to give the Germans every assistance. By contrast, when it was proposed to take steps against the Freemasons, of which there are many in Guernsey the Bailiff made considerable protests and did everything possible to protect the Masons. In Jersey the attitude of the States and of the Bailiff, Alexander Moncrieff Coutanche does not seem to have been quite so gratuitously friendly as it was in Guernsey, but was still very far from being satisfactory.

It was the intention of the Germans in November 1941 to confiscate Masonic property. It is this intention that Cohen identifies in a letter dated 24 November 1941 from Coutanche to Carey, which states, 'We have urged that whatever has to be done, should be done by German Order and not by local legislation.'[43]

The key is that Coutanche wanted to distance the civilian authorities from an unpopular measure involving Freemasons. Neither he nor Carey had such qualms when implementing the anti-Jewish legislation:

> In April 1942, it was the nationality of the island's Jews provided the key to deportation. None of the Jews who had registered in Jersey were deported in April 1942. The Jews of British nationality were protected at that time in the same way as their co-nationals in Guernsey. The one Egyptian national may have been similarly protected from deportation as an Order dated February 1942 stated that Egyptian subjects were to be considered as nationals of the British

Empire. The deportation of Romanian nationals from Jersey would also have been questionable as the matter of the deportation of Romanian exile Jews had not yet been resolved by Berlin. Margarete Hurban, the one German national, may have been temporarily protected as she was married to a German national who was not Jewish. Wranowsky in Sark as a German national was probably only spared as she had appealed against having been classified as a Jew. Dr Casper's request, in June 1942, for clarification from his superiors in Paris on the question of whether or not the 'Jewish Star' Order applied to British Jews, further reinforces the significance of nationality at that time. Despite the Bailiff of Guernsey ordering that the two remaining Jews in the island should be notified of the terms of the Eighth Order and Dr Brosch ordering supplies of Jewish stars, no formal decision appears to have been received from Paris as to the application of the Order to British Jews.[44]

On Alderney, the position of Jewish prisoners was far more precarious. Undoubtedly, many tried, where possible, to hide their Jewish origins. Wilhelm Wernegau, a German prisoner at Sylt, stated that he knew of one Jewish political prisoner transferred in the initial contingent from Sachsenhausen concentration camp. He stated that this prisoner's religion was not known to the SS. A number of those broadly classified as 'Russians' were in fact Jews. Norbert Beernaert, a Belgian non-Jew, testified that 'the Russians were all Ukrainians, one of whom was Jewish. He was revealed by the Ukrainians to the Germans and he was dead within a couple of days. I do not know how he died.'

John Dalmau, a Spanish forced worker in Alderney in 1943, encountered many Jewish forced workers, including a Romanian Jew. Cohen makes a number of observations. Jews were also among the North African prisoners held in Alderney. As regards nationalities of victims, a yellow star found in Alderney after the war emblazoned with the word 'Jude' rather than the French 'Juif' would suggest that it likely belonged to a Jewish forced worker of other than French nationality.

In July, August, October and December 1943, the main transportations of Jewish forced workers from France to Alderney took place. Serge Klarsfeld, the foremost authority on the fate of French Jewry during the Holocaust, identified 700 French Jews sent to Alderney. It would seem that the total number transferred was around 1,000. Two Guernseymen who escaped to England in April 1944, and who had previously worked as fishermen in Alderney, stated in an MI19 interrogation report, 'there are about 1,000 Jews working for the Germans. These are mainly French and wear the yellow star with the word "JUIF" across it'.[45] The Jews transported from France at this time were predominantly middle-class, well-educated professionals, including many doctors, lawyers, musicians and teachers. In addition to French Jews the transportations included Jews originating from other occupied countries.[46]

Cohen quotes from a Jewish forced worker who was sent to a special section of the Alderney Norderney camp:

> I was part of the first batch of French internees to be sent to Alderney. Our task there was to build the island's concrete fortifications. We were put into a barracks

where we slept on flea-infested mattresses. There were fleas and lice everywhere, in your hair even in your eyebrows. We tried to kill the insects when we could, before we went to bed, but we were exhausted.

Albert Eblagon, grandson of the former Chief Rabbi of Crete, worked as a publisher's salesman prior to his arrest. He was transported to Alderney from France in August 1943:

We arrived at night and disembarked on 15 August 1943, at three o'clock in the morning. In the darkness we were forced to run the two kilometres to Camp Norderney, while the German guards continuously stabbed into our backs with their bayonets while also kicking us all the time.[47]

After the war, Eblagon became president of 'Les Amicales des Anciens Déportées de Li'ile Anglo-Normande d'Aurigny', the Alderney survivors' association.

Theodore Haenel was transported to Alderney on 1 October 1943. Born in Alsace-Lorraine, he and his family had first been deported to camps in southern France when their region was 'cleared' of Jews. Being fit and healthy, he was selected for forced labour and sent to a camp in Cherbourg in September 1943. He was then included in a transportation of around 400 Jews bound for Alderney. Of this transportation, approximately 300 were 'Conjoint d'Aryenne'. Haenels' family were transported to Auschwitz, where they perished.[48] Reuven Freidman, born in Lille, was arrested there by the French police in a round-up of Jews and sent by train to Cherbourg in November 1943. On 17 December 1943, at the age of seventeen, he was included in a transportation of Jews bound for Norderney camp. Freidman testified:

We arrived in the middle of the night, and didn't know where we were ... The officer of the camp took out his machine gun, put in on the table and began to read out the camp regulations. In addition to wearing the yellow patch, we had a white stripe the full length of our trousers on both sides ... In the camp there were about 800 Jews.[49]

Henri Uzan, another Jewish forced labourer in Alderney, testified to French war crimes investigators in 1944:

In August 1943, we were loaded onto boats with kicks and shouts. The Germans spat on us from the bridge above us. We stayed like that for twenty-four hours. It was a very rough crossing for everyone. A German, Heinrich Evers, greeted us with slaps, kicks and threats of his revolver. I was carrying two suitcases, and a soldier grabbed them from my hands. We had to march to the other end of the island. These were among us many who were more than sixty years old and who were ill. We were put to sleep in barracks without straw or blankets – only some dried leaves to sleep on. In the morning we discovered that we were covered

with lice. All our luggage was taken except one blanket, one shirt, one pair of trousers and shoes. The German doctor came for twenty-five minutes to inspect four hundred men; he picked out the unfit.[50]

One of the Guernsey fishermen interrogated by MI19 in April 1944 stated,

The Jews wear ordinary civilian clothes with white stripes painted down the outside of their trouser legs. They also wear the yellow star on their left breast. The politicals [political prisoners referred to as 'Stripers'] wear blue and white striped prison garb like pyjamas. The coat, also striped, buttons up to the neck.[51]

Kirill Nevrov, a non-Jewish prisoner at Norderney, remembered the arrival of the Jewish forced workers:

It happened just before we were taken to the Continent. There were a few Russians and Ukrainians left, most had died, but some had already been taken to France ... A few huts were separated from the rest by barbed wire. Special gates were made. It was a camp within a camp, designed specially for the Jews. They were fed separately. In front of the gate two barrels with paint were placed – one with white and the other with yellow paint. The white paint was used to renew the stripe on their trousers every day, the yellow, the star on their backs. Once the Russians noticed that the Jews were hiding something in the pile of wood lying beside one hut. Somebody managed to get there, and dug out golden rings, watches and other precious things. It was but natural to hide the jewellery; the Germans took everything away. Some of the dishonest people benefited at the expense of the Jews.[52]

Georgi Ivanovitch Kondakov recounted:

Later on, already in France, I got into a camp situated close to the harbour [Cherbourg]. The first person I saw there was Levka Pilshikov dressed very stylishly. He had on a fine brown felt hat, a grey suit, a snow-white silk shirt with beautiful cufflinks, a tie and glittering black shoes with long narrow toes. I stared at him in a kind of shock. He looked like a cock on a fence. Looking at me with amusement, he told me that he had found a suitcase with all those fine clothes. It turned out that just before the Russians disembarked from Alderney, a group of Jews had arrived there. The Jews were ordered to leave all their things on the ground. They certainly obeyed, and were transported to the camp.[53]

Albert Eblagon recounted the appalling treatment he received:

There were many men among us over seventy years of age but nobody was spared. Work, hard physical work for twelve and fourteen hours a day, every day, building the fortifications. Every day there were beatings and people's bones were

broken, their arms or their legs. People died from overwork. We were starved and worked to death, so many died from total exhaustion.

David Trat remembered:

They would hit us on the shoulder with planks of wood, just to encourage us to work a little harder. One day I was in the hospital where I saw this man whose wrist had been broken in two places by a beating. He had still been forced to work with a shovel all day before being allowed to have treatment. But the worst thing was the hunger. I was always hungry, I felt as if I could eat non-stop. I was starving night and day. The staple diet was a clear soup, with the occasional small piece of beetroot or sausage and some bread. If you found something solid in your bowl, it was a real cause for celebration.

Many other survivor accounts similarly detail the harsh treatment undergone by both Jewish and non-Jewish prisoners. One Norderney prisoner testified:

Every day the Camp Commander made a habit of beating any man he found not standing properly to attention or who had not made his bed properly or did not execute a drill movement properly. The beatings were carried out on the head, face or body with a stick about 2½ centimetres in diameter. The Camp Commander's assistant also beat workers daily with a stick of the same thickness on all parts of the body until their faces were covered with blood and they could not rise from the ground, when he would call on the prisoner's mates to carry the prostrate body away.[54]

The Jewish section of Norderney camp was under the command of SS Untersturmführer, OT Hauptruppführer Adam Adler and OT Meister Heinrich Evers. Theodore Haenel remembered the camp being guarded by approximately a dozen men predominately recruited from Russian and Ukrainian' units under German command. Norbert Beernaert witnessed Heinrich Evers 'beat people to death many times' and other survivor testimony and interrogation reports confirm his brutality.

Three Russian OT workers imprisoned at Norderney stated to MI19 interrogators in July 1944,

The German camp guards beat … [the forced workers] up pitilessly and for no reason. When the guards got drunk at night all the prisoners were dragged out of doors, paraded and beaten up with the handle shafts of pickaxes. This went on until the shaft broke. Many Russians died under the blows. Frequently the business end of the pickaxe was used.[55]

Gordon Prigent, an eighteen-year-old non-Jewish prisoner sent from Jersey to Alderney at the end of 1943, described daily life in Norderney:

Roll call 06.00; marched to work on stone quarry, dock work or agricultural work; 12.00 – cabbage leaf soup and 1 slice of bread; 12.30 – back to work; 18.00 – march up to 3 miles back to Norderney; ladle of cabbage soup and 1 slice of bread; 19.15 – roll call; 20.00–23.00 – more work.

Prigent detailed the barrack arrangements, where workers slept on three-tier bunks with only straw on wooden boards. Burials occurred on 'several days each week'. Prigent's own teeth were knocked out when he was hit in the face with a rifle butt by a Norderney camp guard. Pantcheff, from the War Office, observes that,

> Several Russians were employed as guards. These hand-picked villains were sent to Paris for a special warder's course before being posted to a camp. They were armed with lengths of sand-filled rubber hosing with which they beat their wards unmercifully.[56]

The Basilov/Pantcheff report confirmed that 'workers were treated atrociously'.

> [The Jews] had reached such a degree of starvation that it was a pastime for the Germans to throw them pieces of carrot and see the pitiful wrecks fighting for it. The human part of the body appeared to be dead but the instinct for survival remained ... Cases of cannibalism were mentioned to me by an elderly Rumanian Jew ... Some of the octopuses and congers [caught whilst fishing] we gave to the Jews who ate them raw.[57]

The report detailed the regime at Norderney and Helgoland:

> Watery cabbage soup plus 1 kg of bread between 5–6 people. Two or three times a week 25gr of butter was distributed, very rarely, if at all, sausage, cheese or fresh vegetables, meat and sugar never ... foreign workers were not given any additional clothing in winter. Foreign workers worked 12 hours a day hard construction work. At midday there was a short break of 10–30 minutes. This regime continued 7 days a week ... only 1 Sunday a month they had a half day.

Cohen continues:

> Whilst food rations were poor for all workers, Jewish forced labourers received less food than other groups of workers. Reuven Freidman testified that on occasional Sundays there was no work and on these days no food was issued. Like many other prisoners he contracted what became known amongst the prisoners as 'flea fever'. Freidman was treated by a Jewish doctor named Rosenfeld and recovered.[58]

In a taped interview with Gordon Prigent at the Imperial War Museum,[59] Prigent repeatedly referred to the guards at Norderney as being SS and those at

the Soldatenheim as 'regular army'. He also stated that as the Allied invasion approached, rumours circulated that the advancing Americans had shot a number of SS guards at a camp in France and, consequently, the SS in Norderney changed their uniforms to those of the Army and Navy. He may have confused the SS uniforms with similar Ukrainian uniforms, or he may have been referring to Adler's SS uniform.

Cohen quotes a Dr J. M. Bloch, a Jewish prisoner at Norderney, who told French investigators in 1944 that a number of work teams had to work sixty-hour shifts with only twelve hours' rest. Cohen reports and observation that,

> We worked sometimes for as long as sixteen hours a day, building concrete walls around the island. Often we worked for twenty-four hours at a stretch, and we were then given half a day's rest before resuming work. My only wish was to rest; it was completely exhausting. I didn't even have the strength to move my hand. On one occasion we were working with the huge concrete-mixing machines and one man was so exhausted he lost his balance and slipped into the concrete. We told the German supervisor that someone had fallen in, but he said it was too complicated to stop the machine. It carried on pouring concrete over him. Many people died at the construction sites. After two or three months people started to die at the rate of about twelve men a day. There was a yard in the centre of the camp where people were shot for stealing cigarettes. In the morning many people were found dead in their beds, and the naked corpses were loaded into trucks. A truck would tip the corpses at low tide into pits dug in the beach fifty to a hundred metres off the shore. There would be about twelve people in each pit. You could never find the grave after the tide had been in and out because sand had been washed over it. I saw the bodies being buried with my own eyes, because I was working about fifty metres away on a concrete wall. [Georgi] Kondakov and I have discussed many times why the corpses were naked. Perhaps it was because people came from work in clothes which were soaking wet, and they would take them off to sleep naked and then die in the night. We also took off our clothes to get some relief from the parasites at night. People stole blankets, but they wouldn't have bothered to steal clothes, because they were no more than rags.
>
> I was nothing but skin and bones, and I had only the clothes I was wearing when they rounded me up in Russia the previous summer, which quickly fell apart. We made replacements out of old cement sacks; we cut off the corners to make holes for the arms and I used a rope as a belt. We used cement sacks for everything: blankets, leggings and even hats. We slept in cement powder because it was softer than our beds. We were covered in cement day and night and our hair got cemented. There was nowhere to wash it off, but it did give us some protection against parasites. My trousers went so stiff with cement that when I took them off they remained standing. I used to be able to jump from my bunk into my standing trousers.
>
> Our huts were about thirty metres long, with men sleeping on either side on two levels of planks. At first it was one blanket per person, but after people began to

die they gave us more blankets. When you lay down you fell asleep immediately; there was no time to feel cold. It was the sleep of a dead man.

There was a passageway about one and half metres wide down the middle. At either end there were doors. There was a rail along the ceiling which the guards would beat with a hammer to wake everyone up. The last to leave the hut was beaten by the guards. We went to the canteen for breakfast, which was only a cup of herb tea that tasted of copper. There was about thirty minutes for lunch, which was cabbage soup; it only took a few minutes to drink it. Supper was more soup and bread. There was a one-kilogram loaf to share between seven people. The flour had been mixed with bone meal and sawdust, so it wasn't like proper bread, and it was as hard as a brick. Occasionally we got 10–15 grams of margarine. Going to the toilet during work was a farce; a German guard would hold out the spade for me to do it on ... Alderney left a mark on the lives of all of us. Each time I go to bed or have a spare minute, I remember the things that happened on Alderney. I want people to know what it was like and to remember what happened.[60]

A German officer stationed in Alderney, despite claiming that the OT workers were 'voluntary' labourers, described their suffering: 'I saw that they were vegetating under the most miserable conditions, really you couldn't call that living ... many of the labourers died through malnutrition, weakness and exhaustion.' He also confirmed that rations due to workers were stolen by their guards.

Francisco Font was a former soldier in the Spanish Republican Army. Sent as a forced worker to Norderney, he witnessed the Jewish prisoners in prayer:

I remember watching how some of the Jewish prisoners would pray. They were not allowed to do this by the Germans. When the barrack Kapo went to another hut to be together with the other Kapos, two men would stand at the doors at both sides of the hut. Then they would pray. Always, there were tears on their faces when they prayed. We used to watch it. This was on Saturdays, some Saturdays. Somehow they managed to put some cloth from shoulder to shoulder, some kind of sacramental thing. I don't know how they managed to keep it and hide it. This was the amazing thing. Somehow they managed also to have the black skull cap that they were not allowed to wear, which they put on their heads, you know, and after the praying was done they used to take it away and hide it, I don't know where. A lot of them joined in the praying and there were tears on their faces. I think their prayers were in Hebrew, as I could not understand the words. It was not French. The majority of them were older men. The younger ones sometimes used to join in but they were more casual. On Friday afternoons some lit candles ... I don't know where they found the candles or the matches, it was a mystery to everybody. They lit them on Friday night, very quiet, very secluded, with somebody standing guard at both doors, Jewish persons, while they had the little ceremony.[61]

Cohen tells us that,

> Some of the Jewish forced workers were drawn towards their Jewish heritage whilst imprisoned in Alderney. Reuven Freidman recounted that he had given a talk to other Jewish prisoners about his dream of emigrating to Palestine after the war.[62]

The forced workers at Norderney were subjected to many terrors. Dr H. Uzan, Dr J. Bloch, a French Jew, and Gordon Prigent each independently described how, at the time of the Allied landings in France, the prisoners of Norderney were forced to assemble in the 'Arch Bay' tunnel near the camp. A machine gun was trained on them and they were told they would be shot if the Allies landed in Alderney. Franz Doktor testified to war crimes investigators that 'all prisoners should be killed if Allied forces landed on Alderney'.

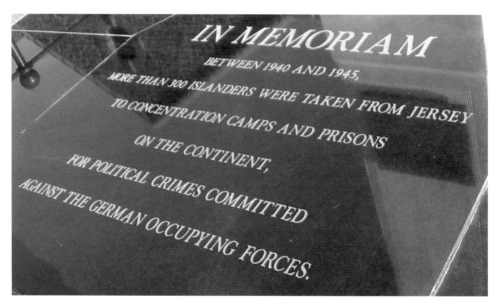

Jersey Occupation Deportation Memorial.

7

Resistance
or Collaboration?

Apart from the odd scuffle and name calling, there had been few serious confrontations between the Occupiers and islanders. Most islanders did their best to avoid the Germans, but a number of local females did court the enemy's attention, and it was not long before they were to be seen clutching the Occupiers' arms ... I viewed their fraternisation with the Occupiers as a treasonable act, as Jersey was part of Britain, which was still at war with Germany.[63]

Of the island women who consorted with German soldiers, Hassall observes of his fellow countrymen that,

we were a friendly lot, and hardly any German felt obliged to carry his personal weapon. They did not need them as we did not rock the boat. There were no partisans in the back to shoot the *Landsers* (soldiers). The Occupier was enjoying himself. No wars! No bullets to dodge! No partisans and no bombs! Cor blimey! What a life Kamerad![64]

With the timeline in mind of 1941, at which time there was little cause to believe the occupation would be anything but permanent, Hassall makes the comment that by the end of the year,

It appeared that some islanders had forgotten that we were British and that the war was still being fought against Nazi Germany. The submissive first six months of the occupation had been a shameful experience to many patriotically minded islanders, and it was more shameful for me, as my parents went out of their way to court the Occupiers ... It was a shameful time during which my respect for my parents reached a low level. I felt that there had to be more honourable ways of making a living than collaborating with the enemy.[65]

In his memoirs, Anthony Faramus, a native of Jersey, aged twenty in 1940, is scathing in his description of occupier-occupied relationships and is quite emphatic in his belief that there was a strong feeling that the Germans would win the war, and that islanders went out of their way to curry favour with the occupying forces. Three months into the occupation, he comments on two perceived dangers: informers and members of the States government. Of the former he says,

> One had to be on guard not so much against the Germans, who often overlooked minor infringements of laws, but against an increasing number of the Occupation's informers of the States government in Jersey, with whom he had a number of problems at Magistrates Court level ... none was more dangerous than certain prominent members of the States government who were seen to be hobnobbing socially with top-ranking German officers in hotels and returning the compliment in the privacy of their own homes.[66]

With the high number of occupation troops on the islands, it could be argued that resistance in any shape or form was pointless. In practical terms, this is correct. Even overt armed resistance would not have forced the Germans to depart, and would undoubtedly have led to deadly repercussions. One of the first acts of the occupiers had been to order the immediate handing over of any device that remotely resembled a weapon. Resistance, however, can take far more subtle forms. Even symbolic acts such as the chalking of 'V' signs on walls annoyed the

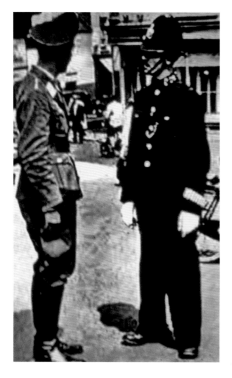

A German soldier and a British policeman.

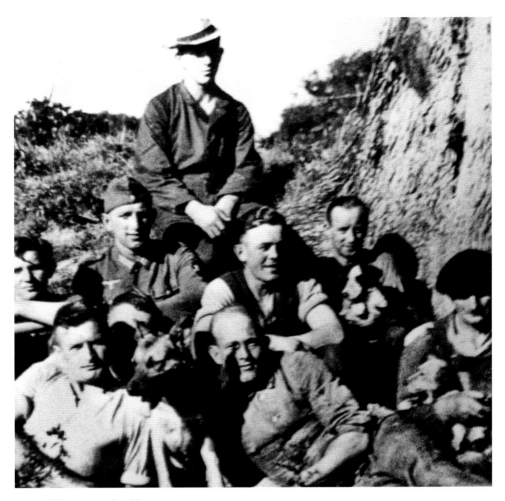

Jersey labourers and soldiers.

Germans, and established a boundary between occupied and occupiers. A complete lack of resistance in any shape or form could be construed as an acceptance and even welcoming of the occupation forces. The need to transform defiance into resistance is probably the reason why a historiography of resistance would develop during the last decade of the twentieth century. It provides a further boundary between collaboration, acceptance, and even the welcoming of the conquering force. A similar historiography has developed in France: the myth of the French resistance hero, the *Maquis*. As a juxtaposition to collaboration, one needs to look at elements of resistance on the islands during this period. If one takes Hassall at face value, there was none, but a literature of resistance has developed over the last fifty years. In looking at elements of resistance, it is well to bear in mind Stalingrad 1943 and Paxton's earlier 1942/43 El Alamein turning points.[67] These were events that led to local populations suspecting that the German war machine not only was not indestructible, but that there was a very real likelihood that the Allies

would prevail. Werner Rings offers a number of categories of resistance. Firstly there is the symbolic resister:

> The symbolic resister says: I signalise my inviolate self-respect by means of personal gestures or actions expressing allegiance to my country, its individuality and right to exist. I do not shrink from conveying to the forces of occupation that they are dealing with a proud and confident people.[68]

Rings gives a number of examples of this sort of resistance, which, in the main, tend not to expose the individual to reprisals, but allow an outlet of feeling. When France fell, the Danish, already under occupation, expressed a form of symbolic resistance:

> It was a spontaneous outburst of symbolic resistance in the truest sense. One Sunday in September 1940, 150,000 Danes gathered to sing in Copenhagen's Faelled Park, another 20,000 at Esbjerg, and over 70 percent of the population at Hasle ... the public squares resounded that evening to the voices of two million Danes, or two thirds of the entire the age of fourteen. The German authorities did not intervene.

Further examples are those of telephone wires being cut in Denmark, a bridge blown up in Oslo and resistance-orientated chain letters in Holland. German wall posters were also torn down in France, the result of which was some communities being fined. In Holland, many Dutch doctors resigned when the medical system in Holland came under Nazification. Many Dutch Trade Union members submitted resignations and refused to pay dues as the Germans quietly attempted to purge them of communist ideology. This is described as a mass exodus. In Norway, on 1 February 1942, Quisling held a special service at Trondheim Cathedral in order to celebrate his appointment as head of government, but nobody showed up, preferring to wait until the postponed afternoon service when 'the cathedral was filled to overflowing, and many thousands of people defied a police ban by standing shoulder to shoulder in the bitter cold outside. Stubborn silence reigned until they all broke into "A safe strong hold our God is still".'

Rings believes that once German defeat became a certainty, symbolic resistance evaporated. According to Rings, the symbolic form of resistance was the only form to prevail until the Battle of Stalingrad was over. With particular reference to the French Resistance, Rings comments,

> The war had already been decided, and the Battle of Stalingrad was over, before it no (resistance) manifested itself at all ... It was not until the summer of 1943 that German situation reports from France spoke of Resistance groups lines, 'some wearing quasi-military a run of variety uniforms, others identified by armbands.' And this was over three years after the fall of France.[69]

Rings notes that time and time again where individuals carried out acts of resistance, the Germans tended to leave them unmolested. After all, these people were

The Dame of Sark and her husband greet a German officer.

demonstrating an innate sense of national pride and nationhood. He demonstrates the nature of the crowd with relation to two French newsreels, one set in April 1944 where a large crowd are cheering Petain, and the other four months later in the same spot, where a crowd, probably the same, cheer de Gaulle. They were both considered, for different reasons, as being symbolic of a sense of nationhood. Rings' second concept of resistance is that of 'Polemic Resistance', in which 'the polemic resister says: I oppose the occupying power by protesting or organising protests, even at risk to myself. I say or do things calculated to persuade my fellow countrymen of the need to fight on.'[70]

The churches are active within this context, encouraging non-violent resistance. In Holland,

They forbade believers to collaborate with the enemy, assisting the detention and deportation of Jews, or hunt down students, runaway workers, and escaped prisoners of war. They more than once sent pastoral letters protesting against anti-Semitic measures and the sterilization of Jews married to Christian women. In February enjoined the faithful to civil disobedience, even at the risk of losing their jobs and suffering other grave disabilities.[71]

Within this category of resistance came the underground press, which were regarded as the spiritual hubs of resistance. Rings believes that there were in excess of 3,500 illegal newspapers within the combined areas of Norway, Denmark, Holland, Belgium, and France. The majority of these papers came into their own during and after 1943.

> The defensive resister says: I take the side of those in danger or on the run: I rally to those who protect them; I defend, by force if need be, the human beings and human values endangered by the occupying power.[72]

Rings' third category of resistance is 'Aid and Protect'. This is the resistance of the underground: safe houses, friendships and escape routes. It was this form of resistance that allowed Allied pilots to escape after being shot down over enemy territory. This category became effective from 1941 onwards and saved numerous lives. Rings gives numerous examples of defensive resistance, but one in particular shows the effects of non-armed and seemingly ineffective resistance that can have the required effect, and bears particular relevance when compared to a number of examples of Channel Island collaboration, and the reasons given for collaborating with regards the enforcement of the anti-Jewish legislation. The Dutch doctors set up their own clandestine association broken into local cells of no more than five members in order to avoid betrayal. Their ethos was that 'they would never collaborate, never turn over Jewish patients to the police or any other authority.'

German soldiers regarded a posting to Jersey or Guernsey as being one of the easiest.

A German officer with his local girlfriend, from the Jersey Tunnel Museum. The caption states 'The young and handsome soldiers could be difficult to resist.'

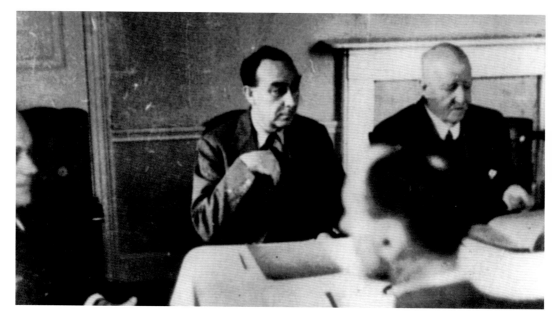

Museum of the German Occupation in the Jersey War Tunnels. The Jersey Bailiff, Alexander Coutanche says, 'When asked by my grandchildren what I did during the occupation I shall say, "I protested".'

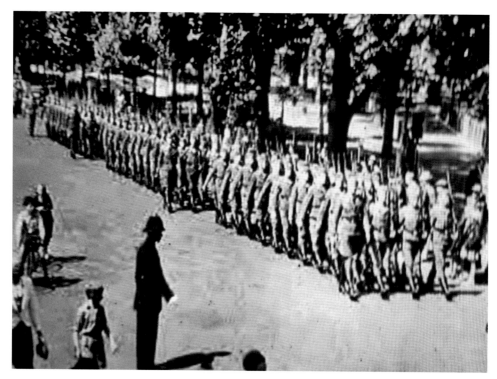

A Jersey parade of German soldiers with a British policeman.

8

The Cover-up

The documents released by the British Government under the thirty-year rule paint a picture of collaboration and outright co-operation by some islanders with the occupying forces. It is clear that men from Guernsey worked on Alderney for the German army providing a large number of basic services including power, drainage, and acting as drivers. They worked as volunteers. Steckoll observes that,

> the co-operation – some would say collaboration – of the island governments with their jackbooted conquerors, which made this extensive internal rule possible was documented in the files of the British Military Intelligence and the Foreign Office, and in the batch of some three hundred documents hidden by the office of the Guernsey Bailiff and by the German Army Headquarters, which after the war somehow surfaced in the Jerusalem Holocaust Archives of Yad Vashem.

Steckoll picks up the following:

War Office document 199/211 2[73]

> QUISLINGS: There are a number of both men and women in the Island [Jersey] who are openly assisting the German Gestapo here. They are informing on their fellow citizens. A list of these is being prepared and will be handed to the Allied Authorities when they arrive in the Island. Among their activities is informing about persons who have kept wireless receiving sets. It is understood that they are paid by the Germans for each person they hand over.

It continues:

> ALIENS: There are quite a large number, about 400, of South Irishmen in the Island. They were here for potato digging before the occupation and remained. They constitute a serious threat to law and order. They are definitely pro-German

and anti-British and should be interned and repatriated. A number of Italians are here, chiefly running cafés which are nothing but sinks of iniquity. They should be interned until repatriated.

WOMEN: The Germans until lately have had licensed French women at two hotels in St Helier for the use of their Forces. Besides these, local women, chiefly Jersey born, have been prostituting themselves with the Germans in a shameless manner. There are quite a considerable number of these women all over the Island. Many of them are the wives and daughters of men who are now fighting in the British Armed Forces. The Island Authorities are powerless to stop it and are paying out subsistence allowance to these women for their illegitimate children. Venereal disease among these women constitutes a further menace to our forces when they arrive here and should be dealt with.

EVENING PRES

 " La Gazette Officielle "

REWARD OF £25

A REWARD OF £25 WILL BE GIVEN TO THE PERSON WHO FIRST GIVES TO THE INSPECTOR OF POLICE INFORMATION LEADING TO THE CONVICTION OF ANYONE (NOT ALREADY DISCOVERED) FOR THE OFFENCE OF MARKING ON ANY GATE, WALL OR OTHER PLACE WHATSOEVER VISIBLE TO THE PUBLIC THE LETTER " V " OR ANY OTHER SIGN OR ANY WORD OR WORDS CALCULATED TO OFFEND THE GERMAN AUTHORITIES OR SOLDIERS.

THIS 8th DAY OF JULY, 1941

VICTOR G. CAREY,

A reward of £25 offered for resisters signed by Victor Carey, Bailiff of Guernsey, later knighted by George VI.

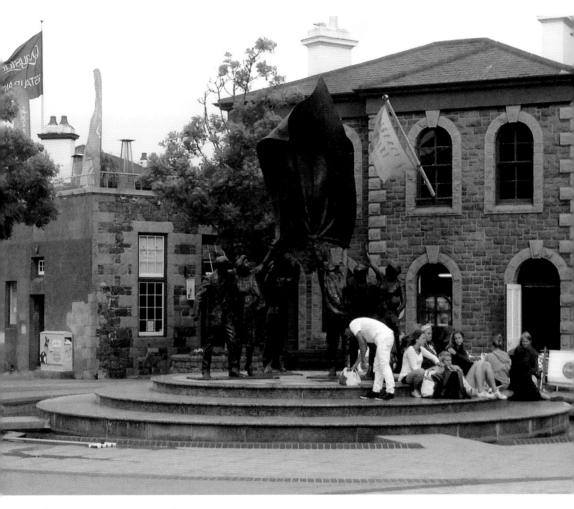

Liberation Square Memorial, Jersey.

BLACK MARKET: Dealing in 'Black Market' is rampant. This is due to meagre rations issued and is practically universal from the highest to the lowest. Jurats, Deputies, etc, are not above it and are some of the worst offenders. Farmers are making large sums of money by holding up supplies and selling them at very enhanced prices to those that can afford to pay. Those who have any stocks of unobtainable commodities are selling what they have at exorbitant prices.

Steckoll is scathing in his assessment of the behaviour of the Guernsey Bailiff who, shortly before the occupation, was appointed to be 'personal representative of the British King for the duration of the German occupation,'[74] and was knighted on 12 December 1945 by the King. Steckoll calls Carey a total collaborator, a charge supported by 'incriminating documents'. He tells us that,

the entire file of correspondence of the Guernsey Island leaders which related to the persecution of the Jews, disappeared from the Bailiff's office and that of the Greffe and of the police. The secreting away of these incriminating documents speaks louder than a thousand witnesses. They would not have been removed from the files and hidden if the authors of the letters did not fear the consequences of exposure, should they come to light.

Steckol says that he found a large batch of the original letters with the signatures of Bailiff Carey and of other members of the British Administration of Guernsey.

The islands were taken peacefully back under British control on 9 May 1945. A number of essays in *The Politics of Retribution in Europe*[75] cover post-war justice in Belgium, Holland and France, as well as a number of eastern European countries. It is the models given that suggest a good reason for a cover up – namely that post-war Europe, including nearby France, was politically and socially unstable. The British Government may have been worried that the Channel Islands would return to France, or that they would become unstable, therefore the course of least disturbance to the ancient regime was best, even if it meant turning a blind eye to capital crimes.

In looking for a model in which to contextualise post-war Jersey and Guernsey within a European framework, we have that given by A. Stepan, who lists four questions with regards to how a regime will undergo the transition from wartime to post-wartime mode and the level of stability. The questions are,

(1) did the population perceive the leaders of the original regime as culpable for the conquest;(2) did the previous leaders collaborate with the occupier; (3) did a resistance movement unconnected to the defeated democratic leadership become a competing centre of national identification and authority; and (4) did the occupation bring enduring changes in the social, economic, and political structures of the country.

Stepan writes:

The more the answer is in the negative for all questions, the more likely it is that the outcome after re-conquest will be the restoration of the previous democratic system, with full legal continuities between the old and new democratic regime.

Culpability would have been seen to lie with the British Government withdrawing and leaving the islanders to fend for themselves, while the second question, in terms of the island governments, was only a question of how extensive the collaboration was. Resistance was not a significant factor and, although there were social and economic changes at the end of the war, these were quickly overridden. Despite the threat to the ruling island elites, this quickly evaporated. Therefore, in the Stepan model, the islands were destined for a smooth transition back to normality. On the surface, this is exactly what happened, but as a society that had been divided,

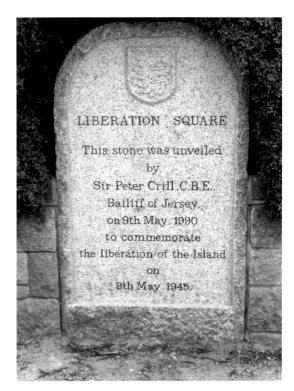

Right: Liberation Square
commemoration, Jersey.

Below: Royal Square, Jersey.

beneath the surface there was festering discontent and a desire for retribution and a settling of scores. In his article 'Justice in Post-war Belgium: Popular Passions and Political Realities', Martin Conway comments that 'post-war justice in Western Europe was imperfect but its purpose was not unworthy, and not all the judgments and sentences were incorrect.' What Belgium did have that the Channel Islands did not was an easily defined Resistance versus Collaboration grouping, which allowed an easy round-up and internment after the war. Popular post-war reaction called for retribution against those who collaborated. As in post-liberation France, there were lynchings, head-shavings and numerous episodes of denunciations. Conway observes that,

> Just as many Belgians had taken pleasure in the assassination of collaborators during the occupation or relished the material sufferings of the Germans in 1945, so they demanded the investigation and, above all, harsh punishment of those guilty men (and, more rarely, women) perceived to have been responsible for their own wartime sufferings.

Post-war Channel Islands did see a limited call for retribution but, unlike Belgium, there were no arrests and only minimal attempts to put collaborators on trial. There was an initial nominal call for a change in the way the Channel Island elites ruled, but this demand quickly evaporated. Part of the reason may be that, unlike Belgium, France and Holland, where there were post-war governmental changes, the Channel Islands saw almost total continuity of the ruling elite, reverting from puppet to full status after the German surrender. Anthony Faramus, a Jerseyman, puts a human face on the desire for revenge or retribution after having been handed over to the German authorities by the Jersey authorities at the beginning of the occupation for delinquent behaviour. He writes after the war from Yorkshire, having survived Buchenwald and Mathausen, to his mother (still in Jersey) of his intention to 'settle old scores'. 'Be on your guard, son,' she wrote,

> 'Those Boche bootlickers still rule the roost, you'll burn your fingers.' I knew what she meant. I knew who and what I was taking on. Despite the years of upset because of the German occupation, only a few hapless women, victims of fate nicknamed 'Jerry-bags' owing to their familiarity towards German soldiers, had come under contempt and hostility; not one word of reproach had been levelled against the real opportunists and collaborators still in States government.[76]

Further accusations of collaboration against Jersey officials led to a Home Office visit warning him to 'pigeonhole' his 'imputations'.[77] Solomon Steckoll, writing in 1982, devotes two chapters to what he regards as a mixture of post-war cover-up and indifference by the British Government. His dramatic writing style is tempered by the reproduction of contemporary British Government inter-departmental correspondence, mainly dated between 22 May and 23 August 1945. He deals primarily with Germans involved with the murder of prisoners and slave workers at

the SS concentration camp on Alderney. Bunting also has much to say of post-war events. She believes there was demand from islanders with five years of grievances for some action to be taken:

> They wanted those who had made money out of feeding the German army taxed; they wanted informers put on trial; they wanted to know if island officials had abused their positions to get extra supplies of food and fuel; and who had beaten their sons or nephews; they wanted the Germans to get their come-uppance.

The comment on 'supplies of food and fuel' is probably a reference to the Faramus comment that Bailiff Alexander Coutanche had been hoarding tinned food after publishing an order prohibiting the hoarding of all food.[78] A Civil Affairs Unit had been attached to the liberation forces with the task of investigating the elements that had been causing disquiet in the British press: war crimes involving Germans, with particular emphasis on alleged atrocities on Alderney, evidence of islander collaboration, and the claims made against the island governments of 'improper' behaviour. As Bunting says of these investigations,

> The story of these investigations is like a jigsaw puzzle from which a number of pieces are missing. Many of the relevant British Government sub-files were destroyed several decades ago. There are no records relating to the post-war period available to the public in the islands' archives.[79]

She describes an initial flurry of correspondence and activity both between the Channel Islands and London, and then London and Moscow. However, despite everything,

> no cases ever came to trial. No German was tried by the British, on the islands or in Germany, for wartime activities on the Channel Islands. No islanders were tried. No criticism was voiced of any of the island governments' actions during the Occupation. Instead, the Bailiffs, Victor Carey and Alexander Coutanche, were knighted, and other senior members of the Occupation governments were also awarded honours.[80]

Perhaps more surprising are the post-war events relating to Alderney. Slave 'workers' from a number of the occupied European countries were maltreated, resulting in thousands of deaths. The predominant nationality was Russian. An MI19 investigator, Theodore Pantcheff, was called in with instructions to liaise with the Soviet Military Mission in London. Pantcheff found evidence of brutality and serious war crimes. He was able to identify suspects still in Allied custody, in all a total of forty-five Germans, and he was able to identify twenty-two Germans who would act as witnesses, all still on Alderney. None of Pantcheff's recommendations were followed through – there were no trials, no prosecutions and the report was subsequently destroyed, leaving no copies in Britain. The reason given was to make 'shelf space.' However, a copy survived in Moscow and was declassified in 1993.

Post-war governmental inactivity with regard to events on Jersey, Guernsey and Alderney must be seen in the wider context of the lack of desire to take any action against collaborators and war criminals that has led to books such as Tom Bower's *Blind Eye to Murder, Britain, America and the Purging of Nazi Germany*[81] and David Cesarani's *Justice Delayed, a Pledge Betrayed,*[82] which examine the seeming contradictions that existed at the end of the war. On the one hand, the loudly proclaimed desire for justice and retribution, and on the other hand, bizarrely contradictory governmental behaviour. Tom Freeman-Keel published *From Auschwitz to Alderney and Beyond*[83] in 1995 to deal specifically with the lack of government commitment to punish the atrocities that took place on Alderney. David Winnick MP raised the matter in 1992 as Kurt Klebeck, the Alderney Camp Commander accused of war crimes[84], was still alive and living freely in West Germany. Freeman-Keel reproduces a series of letters between Winnick and Baron Hermann Von Richtofen, the then West German Ambassador, which makes it clear that Germany would never consider extraditing a citizen for war crimes.

Post-war island events saw some initial turmoil, with signs of discontent. To a much lesser extent than France, a similar pattern of head-shaving and attempted lynchings took place against known, usually female, collaborators. Despite discontent in the British press over the allegations of collaboration, Churchill quickly allowed knighthoods for Carey and Coutanche, probably in an attempt to settle the unrest in the Channel Islands. The knighthoods could be seen as a successful attempt in maintaining the island status quo. Pantcheff's report was commissioned, destroyed and never acted on. There were no collaboration or treason trials.

Opposite: The Channel Islands Liberated, 1945.

PROCLAMATION

People of the Channel Islands: It having pleased His Majesty by Order in Council to vest in the officer commanding the armed forces in the Channel Islands all powers necessary for the success of our operation, the safety of our forces, and the safety and well-being of his subjects in the Islands, I, **ALFRED ERNEST SNOW**, as the officer commanding the forces give you greeting on your liberation from the enemy.

I rely upon you all to work cheerfully and loyally to restore the normal life of your Islands. Your ready compliance with such regulations and orders as may from time to time be issued by me or on my behalf will be in the best interests of the Islands. It will be my firm purpose so to exercise my authority that your own Government may rapidly be restored to your Islands and that you may enjoy in peace and prosperity your customary rights, laws and institutions.

A. E. SNOW, *Brigadier,*

Officer Commanding the Armed Forces, Channel Islands.

10-5-45.

GOD SAVE THE KING.

(SO 5977)

Conclusion

The Channel Islands were not a unique case. They fall comfortably within Wehrner Ring's 'neutral collaborator category'. Sanders' view that the Channel Islands were unique and not comparable to occupied Europe does not hold up. It is clear that there was close co-operation between Germans and islanders at all levels, with strong evidence that many went out of their way to court the occupiers. Rollo Sherwill, son of the president of the Guernsey Controlling Committee, Ambrose Sherwill, told Madeleine Bunting that,

> Newspapers write about the Channel Islands' Occupation in the way they do because this was the only bit of the British Isles which was occupied, and we're supposed to have reacted like the British would. But we didn't behave as British people should ... since the war we have felt like a woman must feel in a rape trial. People accuse her of having led the rapist on. But just as a woman might co-operate for fear of not surviving, so did we.

Within this quote lies the implicit assumption that the British people would have reacted differently. The evidence as provided suggests otherwise. Undoubtedly, the majority of people kept their heads down and continued with their lives. The evidence suggests that relationships between islanders and Germans after an initial period of apprehension settled down to a level of mutual acceptance and respect both at a personal and governmental level. The islanders were pleasantly surprised in that British Government propaganda had led them to expect violation by a square-headed, humourless, primitive Hun. What they were confronted with were ordinary soldiers commanded by intelligent and often aristocratic commanders who, in turn, had been instructed by their superiors that this was to be a 'model occupation' in anticipation of the conquest of mainland Britain. The island governments argued that they provided nothing more than was instructed by the King when he told them to remain between occupiers and occupied. Essentially, this may have been so, but the evidence suggests that up to the period of Stalingrad, the Bailiffs established warm relations with the occupiers, some even continuing socially after the end of the war.

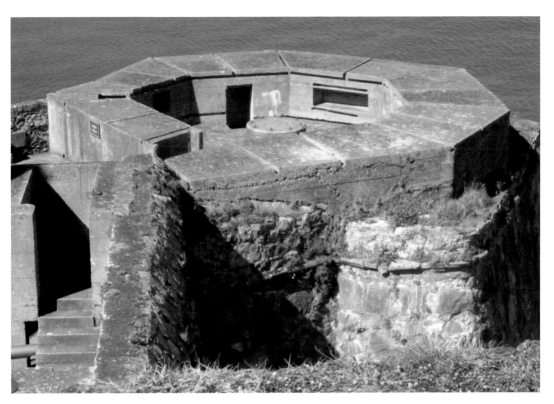

Castle Cornet, 2009.

If there is any claim to uniqueness, it is that the Channel Islands were small, confined, isolated and had a high density of occupier to occupied. This naturally had follow-up effects in that resistance would have been dangerous with nowhere to escape. Two authors in particular represent the island view of the reality, Frank Keiller and Paul Sanders. Frank Keiller, who grew up in Jersey at the time of the occupation, closes his book *Prison Without Bars* with a chapter titled 'Resistance or Collaboration'. In this, he launches a vitriolic attack against both the British press, David Cesarani, who wrote extensively on the Jewish episode, and Madeleine Bunting. He accuses them of causing enormous hurt by emphasising all that was negative (i.e. collaboration), without mentioning those that resisted. While affirming that there were certainly traitors and collaborators, he makes a number of points in defence of Jersey in particular, but attempts to defend the treatment of island Jews in particular, probably because this is a sensitive area that allows direct comparisons with behaviour in countries such as Denmark at one extreme and Vichy France at the other. He argues that not only Jews were deported, and that many of those that were survived. The ones that didn't were foreign anyway. He argues that the Jews, the Bailiff (presumably Jersey?) and his officers were unaware of the horrors of the Holocaust yet to come, and if they had been aware, they would most certainly have not failed to help. Keiller refers to a

memorial service held in Jersey on 2 September 1998 attended by Lord Jakobovits, Emeritas Chief Rabbi, and the subsequent work by the President of Jersey's Jewish Congregation, Mr Freddie Cohen, to provide exoneration, but reference to Cohen's research can be a double-edged sword. Despite being a prominent Jersey citizen, much of Cohen's account and research only serves to confirm Cesarani's view that the island governments co-operated closely with the Germans in rounding up Jews and identifying their property. Keiller uses Cohen's work to portray the events in the Channel Islands as exceptional. Keiller writes that Cohen regarded events as unique 'in that it was the German garrison and its officers that carried it out [the persecution]: not, as elsewhere in Europe, the SS or special anti-Jewish units.'

As in Vichy France, it was the native militia and police that carried out the roundups. The surviving Channel Island sources strongly indicate that it was not the German garrison and officers that carried out orders but the local police force. Keiller then concludes the Jewish matter with the comment that,

> More recently, David Cesarani wrote in the *Guardian* that in the Islands 'co-operation and fraternisation with the Germans was the rule. There were,' he claimed', almost no protests against the application of Nazi race laws.' I am told that Professor Cesarani has since retracted his statement and apologised. I hope so.[85]

Keiller is incorrect; Cesarani has most emphatically not withdrawn this view. It is true that the round-ups and deportations bore little resemblance to those of Poland and Eastern Europe, but their almost gentlemanly implementation led to the same end results. William Bell, in his book *I Beg to Report, Policing in Guernsey during the German Occupation,* reproduces photographs of primary documents on Guernsey 'Island Police' letter headings to the Feldkommandantur, confirming the carrying out of German orders to round up all German, Austrian and Italian civilians, a reference to their Jewish origins being implicit within the context. The island police did the bidding of the Germans:

> The Inspector personally interviewed Julia Bricht and cross questioned her about her parents and grandparents. She told him that as far as she was aware her parents were not Jewish and that she was not Jewish.[86]

Sanders makes a number of valid points in his defence of the negative aspects of the modern study of the occupation. Firstly, that human behaviour is never black or white but tends to manifest itself in various shades of grey. He asks the question as to why 'defiance' failed to materialise as 'resistance'.

He believes the answer is an area for future research. Sanders believes that most islanders simply adopted a 'wait-and-see' approach, as adopted in Europe, and the evidence would suggest that he is correct. He argues that informers existed due to the large rewards offered by the Germans, and the desire to settle personal scores. Resistance was not non-existent, it was simply 'astonishingly piecemeal' and 'individualised' to avoid detection. He continues:

Decidedly, it has to be admitted that most conventional definitions of resistance are difficult to sustain when dealing with the Jersey context. Jersey acts were executed the 'island way'; they stemmed from individual decisions and were conditioned by the great potential, but also the drawbacks of life in an island community. This point is fully illustrated by the example of the Jersey Twenty.[87]

Finally, on the question of 'collaboration or survival,' there is undoubtedly more documentation that will eventually come to light, not least the remaining files being held back by the Ministry of Defence and those files on Jersey and Guernsey still awaiting release. The twelve post-war cases of collaboration passed to the Director of Public Prosecutions were never pursued and the details put on hold until 2045.[88] Again, these documents are without doubt being held to avoid embarrassment.

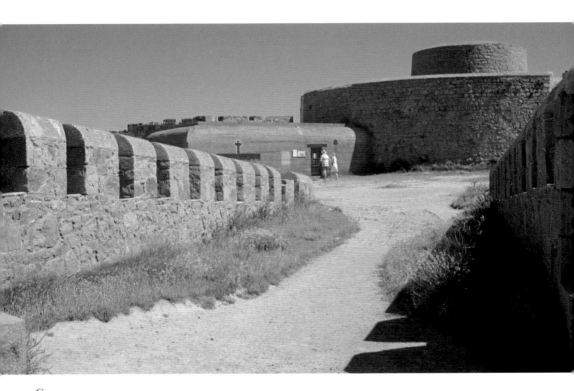

Guernsey, 2010

References

1 Yad Vashem (http://www.yadvashem.org/).
2 Cruickshank, C. G., *The German Occupation of the Channel Islands*(London; New York; published for the Trustees of the Imperial War Museum by Oxford University Press, 1975).
3 Cruickshank, *The German Occupation of the Channel Islands*, p. 152.
4 Sanders, Paul, *The Ultimate Sacrifice* (Jersey, 1998), pp. 106–107.
5 Bunting, Madeleine, *The Model Occupation: the Channel Islands Under German Rule, 1940–1945* (London, 1995), pp.336–337.
6 Toms, C., *Hitler's Fortress Islands* (London, 1978), p. 88.
7 Ward, Stephen, 'Papers Reveal Islanders' Collaboration with Nazis', *The Independent*, 2 December 1992 [http://www.independent.co.uk/news/uk/papers-reveal-islanders-collaboration-with-nazis-1560945.html].
8 Bunting, *The Model Occupation*, p. 41.
9 Bunting, *The Model Occupation*, pp. 42–43.
10 Directive No. 33 quoted in Cruickshank, *The German Occupation of the Channel Islands*.
11 Toms, *Hitler's Fortress Islands*, p. 139.
12 Deak et al., *The Politics of Retribution*, pp. 133–323.
13 Interview with Steckoll, p. 84.
14 Dalmau, J., *Slave Worker in the Channel Islands* (Guernsey, 1956), pp. 16–17.
15 Dalmau, J., *Slave Worker in the Channel Islands*, pp. 18–19.
16 Pantcheff, Capt. T., 'Official British Government Report About the Atrocities on Alderney', Moscow State Archives; Pantcheff, *Alderney Fortress Island*, p. 31.
17 Pantcheff, Capt. T., *Alderney Fortress Island*, p. 7.
18 Kondakov, G. I., B. Bonnard, *The Island Of Dread in the Channel: The Story Of Georgi Ivanovitch Kondakov* (Wolfeboro Falls, NH, A. Sutton, 1991).
19 Steckoll, Solomon, *Alderney Death Camp* (Mayflower, 1982), p. 81

20 Travers, Daniel, The Churchillian Paradigm and the "Other British Isles":
 An Examination of Second World War Remembrance in Man, Orkney, and
 Jersey'. Doctoral thesis, University of Huddersfield (2012) [http://eprints.hud.
 ac.uk/17519/].
21 ibid.
22 Freeman-Keel, Tom, *From Auschwitz to Alderney and Beyond,* Chapter 6,
 pp. 126–166.
23 Ozanne, Beryl S., *A Peep Behind the Screens,* p. 56
24 Freeman-Keel, *From Auschwitz to Alderney and Beyond,* p. 137
25 Ibid. pp. 138–139
26 Kaplan, Alice, *The Collaborator: The Trial and Execution of Robert
 Brasittach* (Chicago, 2000).
27 Cruickshank, *The German Occupation of the Channel Islands,*
 Introduction, p. xiv.
28 Steckoll, *Alderney Death Camp,* p.140.
29 Cruickshank, *The German Occupation of the Channel Islands,* p. 152.
30 Paul Webster, *Petain's Crime: The Full Story of French Collaboration in the
 Holocaust* (London, 2001), p. 101.
31 Robert Paxton, who was educated Washington and Lee, Oxford, where
 he was a Rhodes scholar, and at Harvard, where he earned a PhD, He has
 written other books: *Parades and Politics at Vichy* (1966); *Europe in the
 20th Century* (1975); *Vichy France and the Jews,* co-author R. Marrus
 (New York: Basic Books, 1981).
32 Freeman-Keel, *From Auschwitz to Alderney and Beyond,* p. 17.
33 Steckoll, *Alderney Death Camp,* p. 118.
34 Kaplan, *The Collaborator: The Trial and Execution of Robert Brasillach*
 (University of Chicago Press), p. 31.
35 Deak, Jan and T. Gross, *The Politics Of Retribution in Europe: World War
 II and its Aftermath* (Princeton, N. J., 2000), p. viii.
36 Cruickshank, *The German Occupation,* pp. 113–114.
37 Falla, Frank, *The Silent War* (Guernsey, 1987), p. 20.
38 Cohen, Frederick, *The Jews in the Channel Islands During the German
 Occupation: 1940–1945* [www.jerseyheritage.org/media/PDFs/cijews.PDF].
39 Cohen, *The Jews in the Channel Islands,* p. 12.
40 The Greffier is the Clerk of the Royal and Magistrate's Courts.
41 Steckoll, *Alderney Death Camp,* p. 114.
42 PRO HO 45/22399.
43 Cohen, *The Jews in the Channel Islands,* pp. 91–92.
44 Cohen, p. 88.
45 Cohen, p. 226.
46 PRO WO 199/3303 (a) D15/86 MI19 intelligence report, 20 April 1945;
 and PRO WO 199/2090A (interview 50157).
47 Cohen, p. 231.
48 Cohen, p. 231–232.

49 Cohen, p. 233.
50 Freidman testified that in addition to the Jews arrested in the round ups, other prisoners included black-marketeers, criminals and foreigners with inadequate registration papers. Reuven Freidman, written testimony (Hebrew), Yad Vashem.
51 Quoted from Cohen: PRO WO 106/5248B.
52 Kirill Nevrov stated that in view of his appearance, 'The Germans ... always wondered if I was a Jew.' Georgi Kondakov, *The Island of Dread in the Channel*, (Stroud, 1991), pp. 98, 111.
53 Bunting, *The Model Occupation*, p. 183.
54 Kondakov, *The Island of Dread in the Channel*, p. 112.
55 PRO WO 106/5248B (2376).
56 Pantcheff, *Alderney Fortress Island*, p. 13.
57 Bunting, *The Model Occupation*, p. 183.
58 Cohen, p. 243.
59 Prigent, taped interview, Imperial War Museum and *The Observer*, 1981; Basliov/Pantcheff report, Moscow State Archives.
60 Bunting, *The Model Occupation*, p. 165–7.
61 Steckoll, *The Alderney Death Camp*, p. 87.
62 Cohen, p. 249.
63 Hassall, Peter, *Night and Fog Prisoners*, p. 24.
64 Hassall, p. 24.
65 Hassall, p. 25.
66 Faramus, Anthony, *Journey into Darkness*, p. 36.
67 See Paxton, Robert, *Vichy France: Old Guard and New Order, 1940–1944*, (London: Barrie & Jenkins, 1972).
68 Rings, W., *Life with the Enemy*, p. 153.
69 Rings, p. 162.
70 Rings, p. 163.
71 Rings, p. 172.
72 Rings, p. 175.
73 The term *quisling* was coined by the *The Times* in an editorial published on 19 April 1940, entitled 'Quislings everywhere' after the Norwegian Vidkun Quisling, who assisted Nazi Germany as it conquered his own country so that he could rule the collaborationist Norwegian government himself.
74 Steckoll, p. 121.
75 Deak et al, *The Politics of Retribution*, pp. 133–323.
76 Faramus, *Journey into Darkness*, pp. 233–235.
77 Faramus, p. 235.
78 Faramus, p. 33.
79 Bunting, *Model Occupation*, p. 276
80 Faramus, p. 235.
81 Bower, T., *Blind Eye To Murder: Britain, America and the Purging of Nazi Germany: A Pledge Betrayed* (London, 1981).

82 Cesarani, C., *Justice Delayed.*
83 Freeman-Keel, *From Auschwitz to Alderney.*
84 Freeman-Keel, *From Auschwitz to Alderney* pp. 75–102.
85 *Prison Without Bars*, p. 173. Professor Cesarani confirmed in an email to the author dated 2 July 2003 that he had never retracted his views. He wrote, 'I stand by them 100 per cent. I have certainly not retracted or apologised, nor would I dream of doing so.'
86 Bell, William M., *I Beg to Report* (Guernsey, 1995), p. 74.
87 Sanders, *The Ultimate Sacrifice*, p. 115.
88 Freeman-Keel, *From Auschwitz to Alderney*, pp. 164–165.

Bibliography

Auerbach, Hans, *Die Kanalinseln Jersey, Guernsey, Sark* (A Wartime Publication, dated 1942).

Bell, M. William., *Beg to Report, Policing in Guernsey During the German Occupation* (Guernsey: The Guernsey Press Co. Ltd, 1995).

Bihet, M., *A Child's War: The German Occupation of Guernsey as Seen Through Young Eyes* (Guernsey C. I.: Bihet, 1985).

Bower, Tom, *Blind Eye To Murder: Britain, America and the Purging of Nazi Germany: A Pledge Betrayed* (London :Andre Deutsch, 1981).

Bunting, M., *The Model Occupation: The Channel Islands Under German Rule, 1940–1945* (London: Harper Collins, 1995).

Cesarani, D. Professor, email to author dated 2 July 2003.

Cesarani, D., *Justice Delayed: How Britain Became A Refuge For Nazi War Criminals* (London: William Heinemann, 1992).

Cohen, Frede E., *The Jews in the Channel Islands During the German Occupation, 1940–1945* (Institute of Contemporary History and Wiener Library in association with the Jersey Jewish Congregation, 1998).

Cruickshank, C. *The German Occupation of the Channel Islands* (Guernsey, C. I.: The Guernsey Press Co. Ltd, 1975).

Dalmau, John, *Slave Worker in the Channel Islands* (Privately published, undated).

Deak, I., Jan T. Gross and Judt, T., ed., *The Politics of Retribution in Europe: World War II and its Aftermath* (Princeton, N. J.: Princeton University Press).

Faramus, Anthony, *Journey into Darkness, A True Story of Human Endurance,* (London: Grafton Books, 1990).

Fella Frank, W., *The Silent War.* (Guernsey: Burbridge Ltd, 1987).

Freeman-Keel, T., *From Auschwitz to Alderney* (Shropshire, Seek Publishing, 1995).

Guernsey Star, Friday 2 August 1940.

Guernsey Star, Saturday 28 September 1940.

Hassell, Peter D., *Night and Fog Prisoners,* (Canada: unpublished 1997).

Kaplan, Alice, Y., *The Collaborator: the Trial and Execution of Robert Brasillach* (Chicago: University of Chicago Press, 2000).

Keiller, F., *Prison Without Bars : Living in Jersey Under the German Occupation, 1940–45* (Bradford on Avon: Seaflower, 2000).

Kondakov, Georgi, *The Island of Dread in the Channel* (Stroud, Alan Sutton Publishing, 1991).

Paxton, Robert, *Vichy France: Old Guard and New Order, 1940–1944* (London: Barrie & Jenkins, 1972); S. Martin, 'Robert Paxton: The Outsider', *History Today*, Volume: 51 Issue: September 2001 (pp. 26–28).

Rings, W., *Life With the Enemy: Collaboration and Resistance in Hitler's Europe 1939–1945* (New York: Doubleday & Company, 1982).

Sanders, Paul, *The Ultimate Sacrifice, The Jersey Twenty and Their 'Offences Against the Occupying Authorities' 1940–1945,* (Jersey, C.I.: Jersey Museums Service, 1998).

Sinel. P. L., *The German Occupation of Jersey. A Diary of Events from June 1940 to June 1945* (London: Howard Baker Books, 1969).

Steckoll, Solomon, H., *Alderney Death Camp* (London: Granada, 1982).

Stepan A., 'Paths Toward Redemocratization:Theoretical and Comparative Considerations', in G. O'Donnell, P. Schmitter, L. Whitehead, eds, *Transitions.*

Toms, Carel, *Hitler's Fortress Islands, Germany's Occupation of the Channel Islands,*(Guernsey C.I.: Burbridge, 1996).

Trimel, Suzanne, 'Vichy France to Be Re-examined at Conference Honoring Robert Paxton', *Columbia University Record,* Vol. 23, No. 4 (1997) [http://www.columbia.eduicu/record/archives/vol23/vol23_iss4/16.html].

von Aufsess, M. and Now Ian, Kathleen, *The von Aufsess Occupation Diary* (Chichester: Phillimore & Co., 1985).

Webster, P., *Petain's Crime: The Full Story of French Collaboration in the Holocaust,* (London: Pan Books, 2001).

Winterflood, Herbert, *Occupied Guernsey, July 1940–December 1942* (Guernsey, C. I.: The Guernsey Press Company, 2002).

Guernsey Through Time
Amanda Bennett

This fascinating selection of photographs traces some of the many ways in which Guernsey has changed and developed over the last century.

978 1 4456 3488 3

96 pages, full colour